On the Strange Place of Religion
in Contemporary Art

On the Strange Place of Religion in Contemporary Art

James Elkins

ROUTLEDGE
NEW YORK AND LONDON

Published in 2004 by
Routledge
270 Madison Avenue
New York, NY 10016
www.routledge-ny.com

Published in Great Britain by
Routledge
2 Park Square
Milton Park, Abingdon
Oxon OX14 4RN U.K.
www.routledge.co.uk

Routledge is an imprint of the Taylor & Francis Group.

© 2004 by Taylor & Francis Books, Inc.
Printed in the United States of America on acid free paper.
Typesetting: Jack Donner, BookType

10 9 8 7 6 5 4 3 2 1

Library of Congress Cataloging-in-Publication Data

Elkins, James, 1955-
 On the strange place of religion in contemporary art / James Elkins.
 p. cm.
 ISBN 0-415-96988-3 (hb : alk. paper) — ISBN 0-415-96989-1 (pb : alk. paper)
 1. Art and religion. 2. Modernism (Art) 3. Art--Study and teaching (Higher)--United States--Case studies. I. Title.
 N72.R4E44 2004
 704.9'48'09045—dc22
 2004014164

Modern art is a religion assembled from the fragments of our daily life.

John Updike

[I will not have anything to do with] the self-satisfied Leftist clap-trap about "art as substitute religion."

T.J. Clark

Contents

Preface

Sooner or later, if you love art, you will come across a strange fact: there is almost no modern religious art in museums or in books of art history. It is a state of affairs that is at once obvious and odd, known to everyone and yet hardly whispered about. I can't think of a subject that is harder to get right, more challenging to speak about in a way that will be acceptable to the many viewpoints people bring to bear.

For some people, art simply *is* religious, whether the artists admit it or not. Jackson Pollock, in that view, is a religious painter even though he apparently never thought of his work that way and despite the fact that no serious criticism of his work has perceived it to be religious. Art is inescapably religious, so it is said, because it expresses such things as the hope of transcendence or the possibilities of the human spirit. From that viewpoint, the absence of openly religious art from modern art museums would seem to be due to the prejudices of a coterie of academic writers who have become unable to acknowledge what has always been apparent: art and religion are entwined.

For others, modern art like Pollock's *cannot* be religious because that would undo the project of modernism by going against its own sense of itself. Modernism was predicated on a series of rejections and refusals, among them the 19th-century sense that art—that is, academic art, and mainly painting—is an appropriate vehicle for religious stories. From this point of view a contemporary painting of the Assumption of the Virgin would be in a sense misguided, because it would carry on a moribund tradition of narrative painting last practiced at the end of the 19th century. It would involve a misunderstanding of what painting has become.

For still others, Pollock's paintings might well be religious, but there is no way to construct an acceptable sentence describing how his works express religious feelings. The word *religion,* it would be said, can no

longer be coupled with the driving ideas of art. Talk about art and talk about religion have become alienated one from the other, and it would be artificial and misguided to bring them together.

For yet others, the whole problem is misstated because Pollock might well be religious in some respects and nonreligious or irreligious in others. There is no monolithic *art* any more than there is a property called *religious*. Some would say that words like those are just too diffuse to do much work. What matters is the particular life of a particular Pollock painting. There may be a way to argue that a painting like *Man/Woman* sustains religious ideas, but the correct domain of explanation for a painting such as *She-Wolf* will necessarily be Pollock's mid-20th-century sense of myth, a subject that is a small and specific part of the history of 20th-century religious belief.

And—to add one last point of view—some people would say that Pollock is not the right example to make the case that modernism is not religious, because abstract expressionism effectively erases explicit symbols and stories, substituting incommunicably private and nonverbal gestures. Look elsewhere in modernism, they might say, and you will find plenty of religious art: Marc Chagall and Georges Rouault are the usual suspects, but first-generation abstract painters were religious or spiritual, and even artists like Paul Klee made religious paintings. Or just turn to other abstract expressionists, like Barnett Newman or Mark Rothko: they didn't shy away from talk about religion, even if the religion in their works is private and hard to express in words. Modernism is bound to religion just as every movement before it has been.

Those are just five viewpoints, each potentially at odds with the others. My main purpose in this book is to find a way of talking that can take those five viewpoints on board. A little tale told out of school can show how deep such differences run. When I was half-finished with this book the editor of a major religious press asked to see the manuscript. It struck me that it would be interesting to have the book appear on a religious booklist, and I sent it to him. After considering it for some time, he declined to publish it because, so he said, there was too little religion in it. The art world, as I had represented it, seemed to him to be too much cut off from religion. A year later, a journal called *Thresholds*, put out by the Massachusetts Institute of Technology, asked for an excerpt for a special issue on religion. An editor of that journal, the art historian Caroline Jones, wrote me to say the essay couldn't run as I had submitted it because the art world is in fact wholly saturated with religion, vitiating the difference I was positing between organized religion and the art

market. Eventually the excerpt ran in *Thresholds* with a dialogue between the two of us, intended to help set the essay in its context.[1] For one editor, too little religion; for the other, too much. The two incidents neatly sum up the problem of finding an acceptable approach to the subject, and it may in effect be impossible to write on contemporary art and religion in such a way that the full division of opinions can be fairly rendered.

For people in my profession of art history, the very fact that I have written this book may be enough to cast me into a dubious category of fallen and marginal historians who somehow don't get modernism or postmodernism. That is because a certain kind of academic art historical writing treats religion as an interloper, something that just has no place in serious scholarship. Talking about religion is like living in a house infested with mice and not noticing that something is wrong. I know, on the other hand, that some religionists (as academics tend to call believers outside of academia) will assume I am fallen because I've fallen from some faith.

If you are unsure about my purposes and premises, I ask only that you don't take this opening as the confession of a closet religionist or as a skeptic's disguised polemic against organized religion. I have no hidden agenda, unless it is hidden from me. My own beliefs are not part of this book, and I will not be claiming that modern art is naturally religious, or that religious values are crucial to it. This isn't a crypto-conservative book aiming to reinstate old-fashioned values, and it isn't a liberal tract proposing that the discourse of art be freed of its religious burden. My primary question is abstract: I want to see if it is possible to adjust the existing discourses enough to make it possible to address both secular theorists and religionists who would normally consider themselves outside the art world. To that end I have tried to write a book of reasonably accurate descriptions, a little Baedeker to a world that is at once thronged with strong beliefs and nearly silent.

All that is my first purpose. The second has to do with how art is taught and judged. Straightforward talk about religion is rare in art departments and art schools, and wholly absent from art journals unless the work in question is transgressive. Sincere, exploratory religious and spiritual work goes unremarked. Students who make works that are infused with spiritual or religious meanings must normally be content with analysis of their works' formal properties, technique, or mode of presentation. Working artists concerned with themes of spirituality (again, excepting work that is critical or ironic about religions) normally will not attract the attention of people who write for art magazines. The absence of reli-

gious talk is a practical issue because it robs such artists of the interpre-
tive tools they need most. In the past decade, teaching at the School of the
Art Institute in Chicago, I have found that art students often don't like
to hear words like religion or spirituality applied to their works; and
because of the dearth of conversation on those subjects, students may
even fail to recognize that what they are doing has anything to do with
religion. My second purpose in this book, therefore, is to consider how
best to talk about contemporary art that is reluctantly or even inadver-
tently religious.

I begin by setting out some working definitions, and then I give a
pocket version of the history of Western art and religion. The body of the
book sets to work on the problem of the relation between current art and
religion by setting out five stories, each one about an art student I have
taught. Together the five stories box the compass of contemporary reli-
gion and art: they define its North, South, East, West, and center. The
book closes with suggestions for ways to talk in between art and religion.

I THANK JAN-ERIK GUERTH OF HIDDEN SPRINGS PRESS for first suggest-
ing I write this book, and Sister Wendy Beckett for a lovely short corre-
spondence. Many things about the manuscript changed in light of some
generous criticism given by David Morgan, Brent Plate, and Caroline
Jones. I thank Frank Piatek for a long and thoughtful response. And if
it were not for my *flaithiúlach* editor, Bill Germano, this book wouldn't
exist at all.

It was especially difficult to find a judicious title for this project, one
that wouldn't make it sound as if religion and art have been secretly allied
all along. The artist Joseph Grigely showed me these helpful lines in a
book by a man named Earnest Hooton: "I am also indebted to many of
my friends and students for suggesting a considerable number of titles for
this book, all unacceptable." And what did Hooton decide to call his
book? *Men, Apes, and Morons.* Sometimes the perfect title just cannot
be found.

The Words *Religion* and *Art*

F IRST, IT MIGHT BE HELPFUL TO DEFINE approximately what I mean by the words *religion* and *art*. *Religion* in this book means a named, noncultic, major system of belief.[1] In the art world, for reasons that will become apparent, the religion in question is often Catholicism, and sometimes Protestantism. Rarely it is Judaism. Even more rarely, Islam or Buddhism. Religion also means the trappings of such systems: the rituals, liturgies, catechisms, calendars, holy days, vestments, prayers, hymns and songs, homilies, obligations, sacraments, confessions and vows, mitzvahs, pilgrimages, credos and commandments, and sacred texts. Religion is therefore public and social, requiring observance, priests or ministers or rabbis, as well as choirs or cantors. It involves the family, the congregation, and the wider community.

Frequently I will set *spirituality* against religion as its foil.[2] What I mean by spirituality—again, only for the purposes of this book—is any system of belief that is private, subjective, largely or wholly incommunicable, often wordless, and sometimes even uncognized. Spirituality in this sense can be part of religion, but not its whole. Some of the artists and artworks I will be talking about are spiritual without being religious; they depend on idiosyncratic, individual, and private acts of devotion or senses of belief. I do not equate spirituality with New Age beliefs or with any particular named belief.[3]

Art is whatever is exhibited in galleries in major cities, bought by museums of contemporary art, shown in biennales and the Documenta, and written about in periodicals such as *Artforum, October, Flash Art, Parkett,* or *Tema Celeste.* That way of defining art is called the institutional definition, and it was invented to make it possible to write about conceptual art, performance art, and other new kinds of work that did not fit previous definitions. I am adopting the institutional definition in order to avoid having to say what art should be about, or even what it

has been about. Notice, however, that the institutional definition *does* say something about the content of art, because it excludes almost all art that is openly religious. Such art is not often found in galleries in large cities, nor is it bought by museums of contemporary art, exhibited in biennales, or mentioned in *Artforum* or the other journals. The institutional definition, so it appears, is also a description of a group of institutions that are different from institutions that can make use of openly religious imagery.

Art depends on the existence of the *art world,* and here I come to a crossroads. One way of imagining the art world is to say it is the same as what I have just identified as art, perhaps with the addition of the business end—the buyers, trustees, publicists, auctioneers, and funding agencies. Another way of thinking about the art world is to picture it as a vast arena, containing art as I've just defined it, along with religious art, tourist art, graphic design, commercial art, and children's art. From this perspective, the kind of art I am mainly concerned with in this book is just one of many activities in the art world. In order to distinguish the art I am going to be talking about from, say, commercial art, it can be called high art or fine art. It is interesting that the expression *art world* has this ambiguity built into it: either it is what sustains just fine art, or it is what sustains fine art along with all sorts of other genres including religious art, tourist painting, and so forth.

This is a crossroads because if you think of fine art as one kind of art among many, equal to all others, then the problems I am posing in this book will be empty. Religious art will be one type of art and fine art another, and there will be no particular problem in the fact that one excludes the other. They will be separate but equal. There might be some interesting questions to be asked about why elitist galleries in Manhattan will not show religious paintings, but basically it will be a matter of differing tastes and contexts. Contemporary religious paintings will be appropriate for churches, and contemporary fine art will be found in museums. A hotel might buy some tourist art for its lobby, and a publisher will hire a graphic designer; each kind of art will have its place and purpose. If this sounds about right to you, then you will not have any great problem explaining why contemporary fine art excludes religion: religious art is simply a different kind of art, one among many.

But what if fine art is more than a species in the menagerie of art; what if it is the *source* of other kinds of art? What if the ideas, artistic strategies, meanings, and critical discourses of many kinds of art come from fine art? A hotel-lobby painting, for example, may not catch the interest of a museum curator, but it is very likely that its composition,

style, and subject matter can all be traced to fine-art ideas. (Usually the landscape paintings in hotels derive from French postimpressionist painting.) Chances are that a stained glass window in a church, representing the Crucifixion, will not be of interest to someone organizing the next biennale. But it is probable that the pose of the figure of Jesus, the lighting, and even the arrangement of the window leading are all derived from fine-art precedents. (Typically, a modern-looking stained glass window will derive from a mixture of realism, expressionism, and cubism.) If these things are true, the exclusion of religion from art becomes an intriguing problem. It cannot be a matter of taste, or of the differing purposes of art; it has to be something deeper, a thing that is endemic to the constitution of modern art itself.

I am unconvinced by arguments that the art world is a collection of heterogeneous practices, each potentially equal to the others. That argument ignores the fact that influence usually runs in one direction, from fine art to other kinds of art. (There are any number of exceptions, but that is the rule.) When sociologists such as Pierre Bourdieu disallow the question of influence and try to give equal time to different kinds of art-making, they are also compelled to omit questions of quality and significance—and in doing so they cut what is essential out of the concept of art, making it nonsensical to go on talking about fine art at all.[4] This is a much misunderstood point, so let me say it again a bit differently. The only way to sustain a sense that all kinds of art are potentially equal, with fine art in the mix along with tourist art and religious art, is to give up talk about priority, invention, and history, because nearly any history of tourist art (for example) will depend on prior inventions of fine art. From a sociological point of view concepts such as priority and invention are constructed by and for people who are invested in fine art, so a sociologist might say it is possible to talk about the mix of all kinds of art without considering the logical priority of fine-art concepts. But if you give up talking about invention, quality, and history, you give up so much of fine art that it no longer makes sense to call it art. Quality, priority, significance, invention, art history: these are not contingent properties just because they are socially constructed to serve certain ends. A truly consistent sociological account of art faces the difficulty that after a certain point it becomes impossible to justify spending time studying *art*: all kinds of other things, from key chains to lumber, should be just as interesting. The fact that sociologists spend less time studying lumber than art shows the fundamental inconsistency.

Throughout this book, I will be paying the most attention to fine art and I will be assuming throughout that it is not just one among a field of

equals in the domain of art. (The expressions *fine art* and *high art* are not the best, but they are what is available.) I will be using *art world* to denote fine art together with its economic support, and usually—but undogmatically, and with exceptions—I will be excluding tourist art, children's art, religious art, commercial art, graphic design, and all other forms of art. If you find yourself at variance with these definitions or the assumptions that lead me to them, then this book may pose a problem that isn't a problem for you. In which case I would only say that your sense of fine art might have been compromised (simplified, reduced) by the need to imagine that it is different from and equal to other kinds of art-making.

A Very Brief History
of Religion and Art

O NCE UPON A TIME—BUT REALLY, IN EVERY PLACE and in every time—art was religious. Eight thousand years ago Europe, Asia, and Africa were already full of sculpted gods, goddesses, and totemic animals. According to various accounts there were bull-gods, butterfly-gods, bird-goddesses, frog-goddesses, and deities that were nothing more than lumps of uncarved stone. Neolithic people left offerings, built altars, and chipped at rocks and bones to make images of gods.

Art was religious, or rather ritualistic, back then, and it remained so in the earliest civilizations—in Sumer and Akkad, in Hittite Turkey, in Egypt and Persia. The inception of Christianity did not change art's religious purpose. Figure 1 shows a gentle scene of the Madonna and Child in a landscape, done sometime in the beginning of the third century—a very early date for a Christian image. A prophet stands to the left, raising his arms in the gesture that means "Behold!" The Madonna and Child sit in the shade of a tree hung with oversize flowers. This must have been a refreshing scene to contemplate for the Christians who worshiped in the dank Catacomb of Priscilla, beneath the streets of Rome. I reproduce it here as testimony to the apparently natural relation between late Roman painting and the new Christian purposes for art.[1]

Art continued to serve religion throughout the Middle Ages, in Byzantium, and during the Renaissance. What we call art and what we call religion were inseparable through much of the recorded history of China, India, and Mesoamerica. The same parallel and compatible purposes of art and religion can be found in images made by the Incas, the Scythians and Ife, the Moche and Coclé, Jains and Vedic Brahmans, Parsees and Phrygians, and even the people, whose name is lost, who built the pyramids at Teotihuacán.

It seems that art has been basically religious or ritual in nature, even in times and places where there was no word for what we call religion or

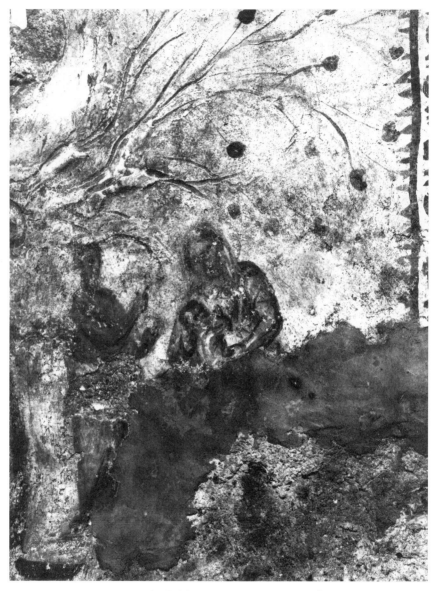

Fig. 1. *Roman, Virgin and Child with Prophet.* Early 3rd c. Fresco. Cata-
comb of Priscilla, Rome. Alinari/Art Resource, NY.

art. In the 20th century, some writers still told the history of art that way, as if art and religion were essentially a unity. André Malraux may have been one of the last; his picture-book called *La Musée imaginaire de la sculpture mondiale* (1952–54) doesn't say much, but when it's leafed through it seems to propose a strange and dramatic religious purpose for the world's art.[2]

The history I am conjuring here is indisputably true, given the meanings we can assign to *art* and *religion*—and yet there is a problem with it. Notice that when I was naming the periods of Christian art, I stopped at the Renaissance. I couldn't quite bring myself to say that art was religious through the Baroque, the 19th century, and into the 20th. There were plenty of religious paintings in those centuries, and even at the beginning of the 21st century there is a tremendous amount of religious art. But something happened in the Renaissance. The meaning of art changed, and for the first time it became possible to make visual objects that glorified the artist and even provoked viewers to think more of the artist's skills than the subject of the artwork.

This is a much-debated subject. Historians such as Hans Blumenberg and Hans Belting and philosophers including Jürgen Habermas have written histories of the West centered on the nature of the change.[3] Perhaps, as Habermas says, modernity—by which he means Western culture after the Renaissance—is only possible in the wake of the dismantling of religion. Given Marx's critique of religion as an illusion of happiness (he also said religion is the heart of a heartless world, the soul of a soulless condition, the halo of the vale of tears, an illusory sun, and the sigh of the oppressed creature—Marx was very poetic on the subject), it can seem that "any return to traditional values (from Catholic or Islamic fundamentalism to Oriental New Age wisdom) is doomed to fail" because it is "impotent in the face of the thrust of Capital."[4] So Slavoj Žižek puts it in his introduction to the 150th anniversary edition of the *Communist Manifesto.*[5]

On the other hand, the Protestant Reformation and Italian Counter-Reformation produced art that remains indispensable for understanding the 16th and 17th centuries. The Protestant iconoclasm was a religious phenomenon even if the current academic interest in the subject is driven mainly by intellectual curiosity about its lingering effects on our current image culture.[6] As art historian David Morgan said, arguing with me on this point, "Who can think of the Enlightenment without natural religion? Who can think of American democracy without Jefferson dissecting the New Testament to extract the moral teachings of Jesus?"[7]

It is a difficult problem. Yet on balance, more is risked by defending the

presence of religion in post-Renaissance art than by insisting on its absence. The best way to get a feeling for the insidious sliding of art away from religion is to look at individual works. In the Renaissance the newly discovered theories of art interceded in art's religious purposes, resulting in artworks that are mixtures of pious sentiments and exhibitions of the artist's skill. Art historians such as William Hood and Georges Didi-Huberman have tried to understand the delicate frames of mind that led painters like Fra Angelico to put humanist skills at the service of pious aims.[8] Fra Angelico's practice was poised between Renaissance inventions that showcased his skill and what we now call medievalizing practices, which were naturally bent to religious purposes. In paintings such as the *Coronation of the Virgin* in the Louvre, an elaborately foreshortened pavement—already an expected sign of a modern artist's skill—is juxtaposed with ranks of medieval-style saints (see figure 2). At the time, the discourse on art did not accommodate such issues; now it seems difficult not to see Fra Angelico's art as if it were a balancing act, even though he may not have thought of it that way.[9]

By the 17th and 18th centuries these differences had become strained. Diego Velázquez's religious images can have a certain studied seriousness about them, as if he were saying all that art can offer to religion is naturalism. I am stating this rather broadly (this is, after all, a very brief history), but it can be seen in paintings like the *Virgin of the Immaculate Conception* (1644), where a breathtakingly beautiful figure of the Virgin stands on a translucent moon. The moon had been understood to be immaculate like the Virgin, but Velázquez's moon has mountains, in accord with the latest scientific discoveries.[10] At first that seems intriguing, but it is also an oddly artificial way for a painting to make contact with religious truth; Velázquez's cratered moon seems to be more a matter of fastidious naturalism than engagement with religion. In a nutshell, this is the quandary of post-Renaissance religious art: how much can naturalism say about the sacred? What else can a painting do except show the glory of the created world?

Bible scenes, crucifixions, and paintings of the Virgin and Child were still common subjects for major artists in the 19th century, but they tended to be handled differently from secular themes. Ary Scheffer is an example of a painter for whom religious commissions called for a special sobriety and professionalism. His *St. Thomas Preaching During a Storm* of 1823 is an instructive example: it is a remake of Eugène Delacroix's *Barque of Dante* from the year before, but Scheffer's figures are studiously posed in plausible positions. They have nothing of Delacroix's fantasy and invention; it's as if Scheffer thought that holy subjects demanded strict

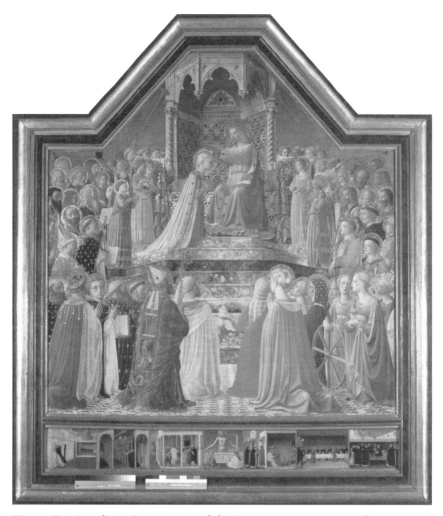

Fig. 2. Fra Angelico, *Coronation of the Virgin*. Paris, Louvre. Alinari/Art Resource, NY.

naturalism.[11] In 1868 Jean-Léon Gérôme painted a lurid and dramatic scene of Golgotha, seen from above with the shadows of three empty crosses falling down and away from us, and a view across a bleak landscape, where a procession winds its way under a dour sky (see figure 3). The painting is brilliantly theatrical, and no more restrained than any Hollywood movie; but it seems that Gérôme thought theatricality could adequately capture religious truth, or even that theatricality *is* religion.[12] Thomas Couture, a half-generation younger, made stupendous paintings of the ancient world, bursting with gold, swags of luscious red drapery,

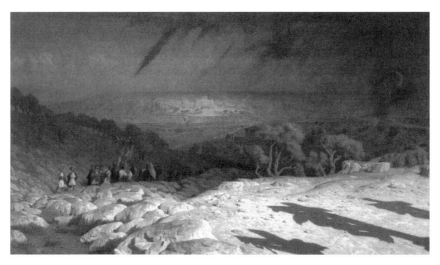

Fig. 3. Jean-Léon Gérôme, *Jerusalem*. *1867*. Paris, Musée d'Orsay. Alinari/ Art Resource, NY.

spilling cornucopias, and dancing maidens. He tried to apply that same large-scale ambition to his religious paintings with unconvincing results.[13] The art historian Michael Fried has said that in order to paint his *Dead Christ with Angels*, Manet had to struggle with the example of Couture's religious paintings. (More on Manet's painting later.) For painters such as Scheffer, Gérôme, and Couture, religious commissions were a duty to be prosecuted soberly and honorably. Painting itself—its highest possibilities and ambitions—was an enterprise that had to be pursued outside of religious contexts.

But this is such a difficult subject. Some 19th-century artists were rabidly atheist (in music, Hector Berlioz is a notorious example), yet many others, including Delacroix, Jean-Auguste Dominique Ingres, and Thomas Cole, practiced their faiths. The problem is knowing when it is relevant to cite such facts in order to understand the painting. The German Romantic painters Caspar David Friedrich and Otto Philip Runge were both religious: Runge was a pious Lutheran, and Friedrich was a Pietist. Runge's paintings called *Tageszeiten* were intended to be put in a Gothic-style church that he designed, and one of Friedrich's first paintings was an elaborate altarpiece.[14] Yet Runge's work was iconographically eccentric and Friedrich's was sometimes stripped of the essentials of religious meaning. Friedrich also experimented with pictures of nature that seem infused with a nameless, almost pantheistic spirit; and Runge made dazzling paintings with idiosyncratic figures that have no straightforward

religious significance.[15] The forms that Christianity took in the work of 19th-century painters such as Friedrich, Runge, William Blake, the Pre-Raphaelite Brotherhood, and Samuel Palmer, were subjective and often inimical to ordinary liturgical use. Palmer began his career drawing weird landscapes where the trees have enormous puffy leaves and the ground is infested by little bugs with stilt-like legs. *A Hilly Scene* is a view onto a field of what—but what a strange field. The stalks are too high and too closely packed, and their panicles are as big as bunches of bananas. A moon looms, symmetrically, over a dark hill, and trees bend from either side, forming the ghost of a Gothic arch (see figure 4). The early work is clearly visionary and religious in intent, but it is an open question how

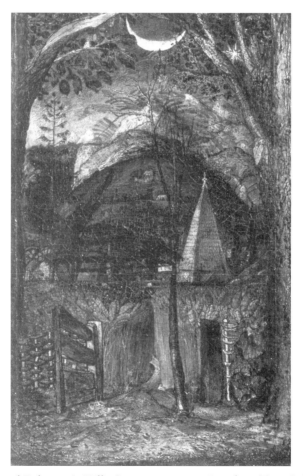

Fig. 4. Samuel Palmer, *A Hilly Scene*. 1826–28. London, Tate Gallery. Alinari/Art Resource, NY.

to read such eccentric religious markers.[16] Gradually, the most inventive and interesting art separated itself from religious themes. By the time of the impressionists, it did not seem there was any room left for religion. Monet was too preoccupied with light and color; Seurat was too much bent on achieving the next stage of painting; Cézanne too invested in being truthful to nature. At the same time, religious themes kept rising to the surface like half-sunken boats. Van Gogh had very passionate, if obscure, thoughts about how his art worked as religion. No good account of his confused thoughts on art, nature, miracles, and divinity has yet emerged from the literature, and art historians tend to avoid the subject. The book *Van Gogh and Gauguin,* for example, skims over the religious meaning of paintings such as *Starry Night* in favor of an analysis of the picture's geographical location and its secular literary sources.[17] At the turn of the century, painters such as Fernand Khnopff, Edvard Munch, and Odilon Redon worked in personal, sometimes mystical spaces between painting and poetry that are especially difficult to disentangle.[18] Who can say what is tempting St. Anthony in Khnopff's 1883 painting of that subject? St. Anthony stands in profile, confronting a gleaming asymmetrical golden light. No obvious demons or temptresses here, and no allegiance to a namable religious doctrine.

Now, a hundred years later, it appears that religion has sunk out of sight. Artists in the mainstreams of modernism, beginning with Cézanne and Picasso and including the surrealists, were increasingly stringent and explicit about their distance from religion. Surrealism's rejection of religion took a particularly intransigent form on account of Freud's critique, in which God is imagined as a projection of fundamentally sexual desires. It is telling that the major book connecting surrealism to religion, *Surrealism and the Sacred,* is written by an historian of religions and not an art historian; it has more affinities to an anthropology of images than to the historiography of surrealism.[19]

Postmodern art has only made the break more decisive. Pop art, minimalism, conceptual art, video, and installation art seem miles away from religion. Such art can often be *read* as religion—that's a theme for later in this book—but it is not often intended to be religious. If you pick up one of the surveys of 20th-century art, like H.H. Arnason's *History of Modern Art,* you might get the impression that artists stopped working for the church around the time of the French Revolution.[20] Arnason begins his book with a lightning review of premodern art from Van Eyck to Raphael, including Matthias Grünewald's nearly insane *Isenheim Altarpiece* (1512–15, Colmar, France). Leafing through the 800 pages that follow reveals almost no works on religious themes. There is a photograph

of Barnett Newman standing rigidly in front of his paintings of the *Stations of the Cross* (1966, National Gallery of Art, Washington, D.C.), each canvas reduced to a severely abstract pattern of "zips," as he called them (stripes against a white ground). On another page you will come across one of Emil Nolde's religious paintings, the *Last Supper* (1909, Copenhagen), painted—along with other scenes from the life of Christ— when Nolde was in a kind of ecstatic trance (see figure 5). There is also a reproduction of Salvador Dalí's *Christ of St. John of the Cross* (1951,

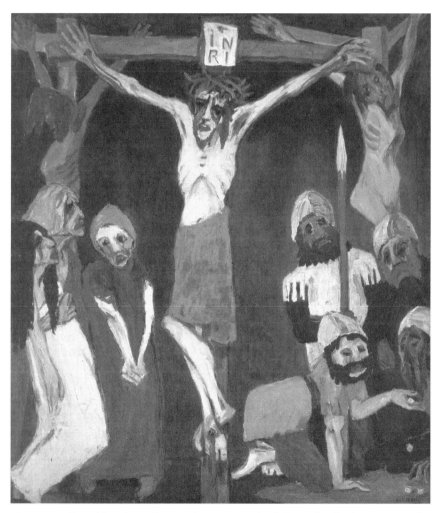

Fig. 5. Emil Nolde, *Crucifixion*. Center panel of the Life of Christ triptych. 1911–12. Seebüll, Ada und Emil Nolde Stiftung. Alinari/Art Resource, NY.

Glasgow), but there you might begin to wonder if the work is really religious or if it is more a matter of Dalí's "paranoiac-critical" surrealist method. After all, the crucified Christ is shown hovering head-down in a deep azure sky; he reminds me of the enormous spacecraft that floats overhead in the movie *Close Encounters of the Third Kind*. (It is curious that Dalí's painting hangs in one of the few museums dedicated to religious art, the St. Mungo Museum of Religious Life and Art in Glasgow. It is given a place of honor there, as if it is an emblem of modern spirituality.) Just a few other artists out of the thousands in Arnason's book depict religious themes: among them Rouault, Chagall, and the English painters Graham Sutherland and Francis Bacon. Arnason chose one of Bacon's gruesome early pictures in which the crucified Christ is replaced by an animal carcass. A monstrous man in a business suit sits beneath, with an umbrella to keep the blood from pouring onto him. It is hardly the kind of religious image that could be placed in a church.

Among these slim pickings there is only one work that is actually in a church, Matisse's designs for the little Chapel of the Rosary of the Dominican nuns in Vence, France (1951). It might be the only example of 20th-century painting that is both a consecrated religious work and also a certified member of the canon of modernism. Jean Cocteau's church murals in Villefranche-sur-Mer just east of Nice, France, and in the chapel Saint-Blaise des Simples in Milly-la-Forêt, are often reproduced (though not in Arnason's book), but they are not the most important of Cocteau's works. Maurice Denis's chapel in Saint-Germain-en-Laye, outside Paris, is a fascinating example of modernist Catholic art, but it is seldom considered alongside contemporaneous nonreligious modernism. (There is an adjoining museum full of Denis's religious work; see figure 6.) Matisse's is the only canonical modernist example. Toward the end of Arnason's book there is no religious art at all. Instead there is page after page of abstraction and pop art, all of it free of religious motifs.[21] (That is not to say that the book itself is secular. The pages are filled with works that look as if they might be spiritually inclined—but that is not my subject yet.)

And then there's the strange and depressing museum of modern art at the Vatican, the Collezione d'Arte Religiosa Moderna. It includes paintings by Matisse, Ben Shahn, Graham Sutherland, Otto Dix, and Carlo Carrà; but it peters out, like Arnason, when it comes to more recent work. When the museum was opened in 1973, Pope Paul VI gave an optimistic speech about contemporary art's " 'new sister,' contemporary art and the spirit of the age"; but the museum had few contemporary works, and even those were not representative of current art parctices.[22]

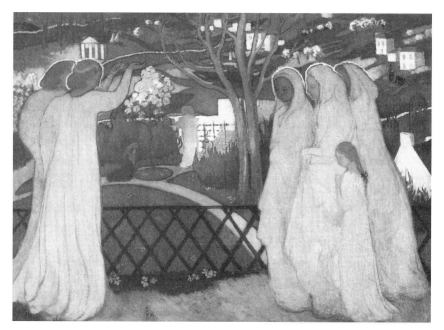

Fig. 6. Maurice Denis, *The Women Find Jesus's Tomb Empty* (Luke 20: 11–18). 1894. Musée du Prieuré, Saint-Germain-en-Laye. Alinari/Art Resource, NY.

Contemporary art, I think, is as far from organized religion as Western art has ever been, and that may even be its most singular achievement— or its cardinal failure, depending on your point of view. The separation has become entrenched. Religion is seldom mentioned in art schools and art departments, partly because it is understood to be something private (what I am going to call spiritual), and partly from a conviction that religious beliefs need not be brought into the teaching of art. When religion does come up in the art world, it is because there has been a scandal: someone has painted a Madonna using elephant dung, or put a statuette of Jesus into a jar of urine.[23] Very occasionally an artwork will appear that presents itself as sincerely religious. Christian Jankowski's video *The Holy Artwork* (2001), in which a television preacher lays hands on the artist and then preaches about "holy art," seemed to some viewers as a genuinely religious work that is also fine art.[24] But aside from the rare exceptions, religion is seldom mentioned in the art world unless it is linked to criticism, ironic distance, or scandal. Art critical of religion is itself criticized by conservative writers, and it is noted with interest by art critics,

but sincerely religious art tends to be ignored by both kinds of writers.[25] An observer of the art world might well come to the conclusion that religious practice and religious ideas are not relevant to art unless they are treated with skepticism.

And that's odd, because there is a tremendous amount of religious art outside the art world. People gather to see miraculous images that seem to weep real tears, and the stories make the evening news. In the 1990s a Moiré pattern in the glass of a curtain-wall office building in Clearwater, Florida, was interpreted as an enormous apparition of the Virgin Mary. The iridescent image, captured in a snapshot, looks like the outline of any Renaissance or Baroque painting of the Virgin.[26] There are dozens, hundreds, more examples: I remember seeing crowds looking at what they took to be apparitions in paintings, stained walls, roots, and tin roofs, all shown on local television in Chicago. In America such reports are much more common than in Europe. They testify to a widespread interest in images—I wouldn't quite call them art—that have religious significance.[27]

In 1999 Sister Wendy Beckett judged an international competition called "Jesus 2000" in order to find the best image of Jesus for the millennium.[28] There were over a thousand entries from 19 different countries. Sister Wendy's pick for the winner was Janet McKenzie's *Jesus of the People,* a painting of Christ as a Black man (see figure 7). Christ's body had been modeled from a woman's body, and McKenzie painted three symbols in the background: a halo, a yin-yang, and a feather. (Sister Wendy thought the feather was a sheaf of wheat or a lance, but McKenzie intended it as a feather, symbolizing either "transcendent knowledge" or "the Native American and the Great Spirit.")[29] The contest was written up in newspapers across the country. One report I saw appeared in the Corpus Christi, Texas, *Caller-Times:* it describes a local woman's entry, which was a depiction of Jesus as a middle-aged man wearing a baseball cap, standing on a country road with a dead-end sign in the background.[30] The artist explains that she first modeled her figure of Jesus on a homeless man, then gave him her father's body, her own hair, and her daughter's nose. In the newspaper, the painting is presented as a touching act of devotion, but it is out of the question as art.[31]

I think the conclusion of this history has to be that fine art and religious art have gone their separate ways. The distinction can be made visible in many ways. In Berkeley, for example, the University of California has a Theological Union and an Art History Department. The members of the two faculties have amicable relations, but the purposes of the two departments and their understandings of art are radically different. Students in the Theological Union study for religious vocations, and they tend

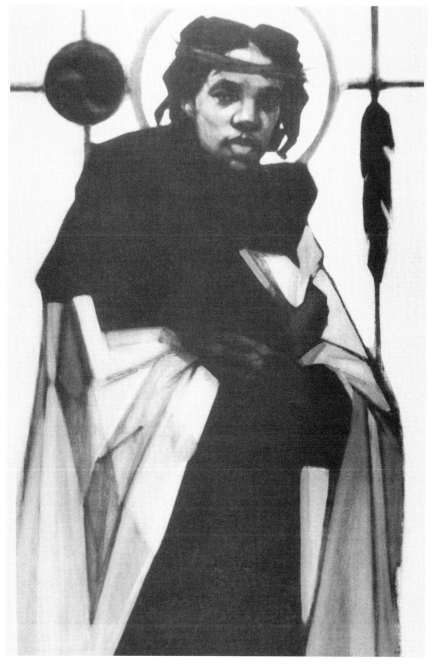

Fig. 7. Janet McKenzie, *Jesus of the People*. 1999. From Jesus 2000, special issue of the National Catholic Reporter, December 24, 1999, cover.

to be interested in art as a spiritual vehicle. Students in the Art History Department are preparing for careers as college professors and curators, and when artworks happen to be religious they take note of the fact just as they would if the art were politically oriented, or concerned with gender, or of interest for its recondite allusions—the religious content is just one more thing to study.

Outside the university, the difference between fine art and religious art can be seen by visiting people's homes. An observant Catholic family in suburban America is likely to have religious paintings, posters, and statuettes around the house, mixed in with paintings and sculptures that are displayed as artworks. The two kinds of images are thought of differently and bought in different places. The artworks in the house are likely to be reproductions of images studied in university and college courses on art history. A house might have a poster of Jean François Millet's *Angelus* in one place, and a print of the Sacred Heart in another. A few images cross over and work as both art and religion—especially the popular painting by Rosso Fiorentino called *Musician Angel* (see figure 8), *and* for an earlier generation, Raphael's *Sistine Madonna* (see figure 9).

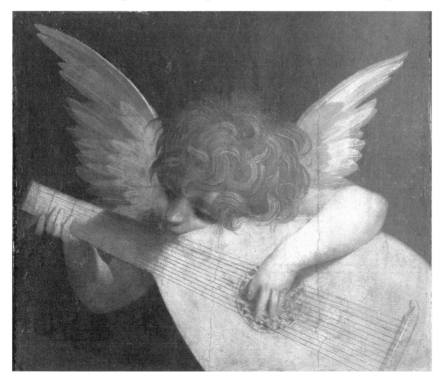

Fig. 8. Rosso Il Fioerntino, *Musician Angel*. Florence, Uffizi. Alinari/Art Resource, NY.

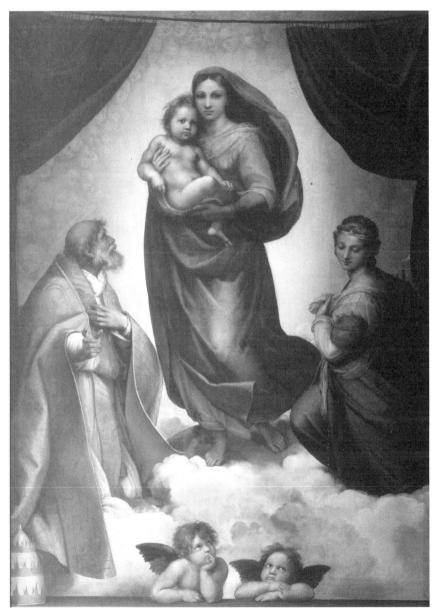

Fig. 9. Raphael, *Sistine Madonna*. 1513–14. Gemáldegalerie Alte Meister, Dresden. Alinart/ArtResource, NY.

Those exceptions aside, the religious images are unlikely to be found in college curricula because they are not considered part of the world of art.

As a rule ambitious, successful contemporary fine art is thoroughly nonreligious. Most religious art—I'm saying this bluntly here because it needs to be said—is just bad art. Virtually all religious art made for homes and churches is poor and out of touch. That is not just because the artists happen to be less talented than Jasper Johns or Andy Warhol; it is because art that sets out to convey spiritual values goes against the grain of the history of modernism.

How Some Scholars Deal
with the Question

PEOPLE IN MY PROFESSION CONSIDER SUCH THINGS AS "Jesus 2000" untouchable. Some scholars who study visual culture might be interested in the "Jesus 2000" contest because it is part of a widespread phenomenon in popular culture. That sociological approach avoids the problem of the art's quality and importance in order to consider it, dispassionately, as a fact of contemporary life. I can imagine some art critics becoming interested in McKenzie's painting because it is "so bad it's good"—that is, it conforms to Susan Sontag's original definition of camp.[1] For the most part "Jesus 2000" has no place in contemporary academic thinking on art.

There are a few art critics and art historians who write about the religion and spirituality. Suzi Gablik, Donald Kuspit, Joseph Mascheck, and Robert Rosenblum approach the subject from different perspectives, but they have each affirmed the importance of spirituality in art and the necessity of distinguishing spiritual from religious art.[2] Mascheck, in particular, is vexed by the art world's secularism and by Catholicism's conservatism.[3] It is far more common to find scholars writing as neutral observers of past religious practices. For a mainstream art historian studying Titian, the religious content of the painting is a matter of academic interest, because it tells us something about Titian's ideas about painting and about his patrons' expectations. An art historian would not normally consider whether Titian's enormous *Assumption of the Virgin* might in some sense be a picture of heaven as Titian believed it to exist. Given the sophisticated and often cynical intellectual climate of Titian's Venice, it seems terribly unlikely that Titian could have thought that heaven is occupied by rows of saints in elegant ochre and vermilion robes. But his paintings do seem to profess faith, at least in the sense that they are evidence he believed painting could be adequate to the task of depicting faith. An art historian would normally say such questions about Titian's faith are unan-

swerable, and that what matters is the way that the *Assumption* was received and how the subject is handled in the painting. This is not to say there is a lack of scholarly books on religious art. Books such as *Divine Mirrors: The Virgin Mary in the Visual Arts* can be elaborately sensitive to religious meanings, but they are not themselves religious; they chronicle other people's beliefs with the same scrupulous sympathy and intellectual detachment that you might give to someone explaining his or her own religion. Hans Belting's *Likeness and Presence,* perhaps the best book on the slow disentangling of art and religion, is not itself a religious book: it makes no judgments on art or religion.

Religion is even further from art history's understanding of modern and postmodern art. I think the people who avoid talking about religion together with contemporary art are absolutely right. I couldn't agree more with the ferocious observation made by the art historian T.J. Clark, that he doesn't want to have anything to do with the "self-satisfied Leftist claptrap about 'art as substitute religion.' " Clark is right because serious art has grown estranged from religion. Religious artists aside, to suddenly put modern art back with religion or spirituality is to give up the history and purposes of a certain understanding of modernism. That separation is fundamental for a number of art historians. Karl Werckmeister has said that even Clark "relapses into a romantic, middle-class penchant for substituting art for religion" by juxtaposing a story about the modernist alienation of art and reality with a nostalgic glimpse to a previous period in which religion was preeminent. In other words, just by putting the two themes together on a page Clark betrays the "middle-class" nostalgia that he works so hard to think through, if not to finally extinguish.[4]

And yet there *is* something religious or spiritual in much of modern art. Somewhere John Updike calls modern art "a religion assembled from the fragments of our daily life," and I can see the truth in that notion, just as I can agree with Clark. (I've juxtaposed Clark and Updike as dual epigraphs to this book: two irreconcilable polar opposites, temperamentally and philosophically disjoint.) Yet it does seem awkward to be unable to speak about the religious meaning of works that clearly have to do with religion. The first generations of abstract painters, for example, were full of spiritual and religious enthusiasms. Current scholarship on Mondrian, Malevich, Kandinsky, and others tends not to focus on their theosophy or their mystical beliefs as much as on their philosophic theories and their senses of history. But how far is it possible to go without the quirky, apocalyptic, and messianic notions that drove first-generation abstraction? Clark does say that he would like to find out how "God Is Not Cast

Down" by modernism (the quotation is the title of an essay by the painter Kasimir Malevich), but he does not come close to speaking about it.

It has proven difficult to write sensibly about modernism and religion. The French political historian Alain Besançon, who has written a history of divine images from the Greeks to Mondrian, tends to draw on philosophy rather than art history for his explanations. He knows it is a problem, but it seems inescapable. "It is not necessary to refer to Hegel and Kant to understand modern art," he says, but he finds it very difficult to break the habit, and his book is really a history of Plato, Plotinus, Augustine, Calvin, Pascal, Kant, Hegel, and Schopenhauer, and only incidentally Cézanne, Picasso, Mondrian, and Kandinsky.[5] Other writers draw on theology for their explanations: the Protestant theologian Paul Tillich, for example, saw modernism through the lens of religious doctrine.

There are signs that the secularization theory of modernity might be losing its grip. Scholarship on American art in particular has recently become more open to religious meanings. Sally Promey, Kimberley Pinder, David Morgan, and others have been exploring religious meanings in American art, and some European scholars have been following suit.[6] One of the few texts written from a European perspective on the subject of religious meanings in modern art is Thierry De Duve's *Look, One Hundred Years of Contemporary Art*.[7] Near the beginning De Duve raises the problem of looking at work that would—if it weren't modern—be considered as religious art. His example is Manet's painting *Dead Christ and the Angels* from 1864 (see figure 10).

De Duve takes note of several religious inconsistencies in Manet's painting. A rock in the foreground records a reference to the Gospel according to John (20:11–18), where Mary Magdalene looks into Christ's tomb and sees two angels where Jesus' head and feet had been. In the painting, Jesus is still there, and as De Duve notes, his eyes are slightly open. In art historical terms, the picture is a combination of four moments that are usually depicted in separate paintings: the episode in John 20; the Dead Christ, which was depicted by Hans Holden and others; the Deposition, in which the body of Jesus is brought down from the cross; and the Pietà, in which Mary holds the dead Jesus, sometimes with angels in attendance. Because Jesus' eyes are open, the painting also refers to a half-dozen episodes in which the resurrected Christ appears to Mary Magdalene and the Apostles.[8] Hence the painting may compress more than ten overlapping episodes: it is not possible to make an exact count. A list of the nearest sources would be enough to secure an art-historical analysis

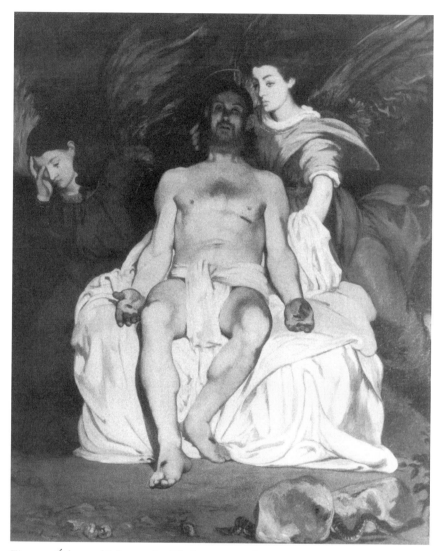

Fig. 10. Édouard Manet, *Le Christ mort et les anges [Dead Christ and the Angels]*. 1864. New York, Metropolitan Museum of Art.

of the painting. The *Dead Christ and the Angels* would be an innovative attempt to make a single painting out of several religious narratives.

De Duve wants to know what meaning this experiment in religious meanings might have *as painting*. "The best modern art," he says, "has endeavored to redefine the essentially *religious* terms of humanism on *belief-less* bases," and he cites Kasimir Malevich's abstract painting *Black Square on White Ground* as an "inoculation" of the Russian icon "with a vaccine capable of preserving its human meaning" for a period when the faith in God could no longer sustain human meaning.[9] That kind of formula follows from the observation that "faith, for us, has become a private matter to be settled according to individual conscience. And religious practice is no longer the social mortar it once was." I do not want to subscribe either to that assumption about faith or to the interpretation of Malevich that follows from it, because I would rather leave those large questions open. (In the terms I am setting out here, the "private matter" of faith is spirituality, and the "social mortar" is religion.) But I cite De Duve's assertion in order to introduce the very interesting conclusion that De Duve then draws: he says that "only the beholder's gaze can bring back life" to this "Christ touched by loss of faith and despair." So, leaving aside the possibility that the painted figure is "touched by loss of faith and despair," in what sense, exactly, can the "beholder's gaze" restore the painting's religious meaning?

It is certainly true that in the context of the Salon where it was first shown, Manet's painting was not religious. It was a work of art, "offered to the hordes jockeying their way into the Salon to see some art, pass the time, be seen and flaunt their attire, and, in the best scenario, brush up on culture a little, maybe even to seek out the soul which the materialism of modern life has deprived them of—but definitely not to perform their devotions." The best of the viewers would perhaps stop, really look, and begin to "wonder about the Christ in this astounding painting, [saying] 'Perhaps he's in the throes of rising from the dead under the wings of two attendant angels.' As if the mere willingness to let oneself be visually touched by the picture were tantamount to an act of faith."[10]

That's it, in that last sentence: the idea that merely looking, and allowing yourself to be moved, might be an act of faith that answers what the painting proposes. Such a viewer no longer asks what Manet was trying to do by conflating a half-dozen particular episodes in the life of Christ. What matters is only to notice that the painting does not behave itself in proper religious or art-historical manner; that is enough to signal that something else is going on, that Manet was trying to do something *in painting*, and not in doctrines.

"Belief or non-belief in the Gospel doesn't play much of a role in the judgment of the critics of [Manet's] day," De Duve continues. "Cultural habit and mental sloth, on the contrary, do play quite a considerable part. We think we're seeing a church painting because that's just what it looks like, and that's enough to stop us from asking what meaning a church painting, *painted for a Salon,* might have."[11] It seems right to say that the uncanny power of the "still dead gaze which stares deep into our eyes" provokes a "doubt" about the usual ways of interpreting religious pictures. I am not as sure about De Duve's conclusion that the doubt "becomes the vaccine against the loss of faith," although it does seem plausible that it might be, as De Duve says later in the book, "the vaccine for loss of faith in art."[12] What happens, I think, is less dramatic and more abstract. Looking at Manet's painting, you realize that the concatenation of biblical references is not the point; the point must therefore be that the concatenation itself is intended to provoke the thought that a painting has to remake religious meanings *as painting.* "We cannot separate faith in God from faith in painting . . . as easily for the 19th century as we think we can nowadays," and Manet's painting does ask for an act of faith in both: the painting makes us ask how much we might have faith in the painter, or in painting, and that leads, by a subtle thread, to faith in religious meanings that might be communicated *only* in painting or only in this painting.

There is so little writing on this subject that it feels odd to keep going. Certainly the argument I am extracting from De Duve's book does not work as orthodox theology; you can't make a collage out of a holy narrative and expect that it will result in a truth that fits together. Nor is it clear what is meant by a religious truth that can be expressed only *as* painting. In past centuries, religious truths were expressed *in* painting, meaning with the help of painting, or simply using painting.

In order to believe that Manet's idiosyncratic picture can function as a "vaccine" against what De Duve calls the "loss of faith," you have to subscribe to his assertion that "faith, for us, has become a private matter to be settled according to individual conscience." Such a faith could, I suppose, be reinstated by the "vaccine" of painting. Without De Duve's assumptions about the erosion of religion and the rise of private "faith," the painting cannot operate that way. What it can do is tentative and tenuous: it can provoke thoughts about how modern painting might address religion by putting itself in question. What is the *Dead Christ and the Angels,* exactly? It is a modernist painting, but one that risks undoing itself in order to have something to say about religion through or as painting. It is not at all clear what the painting does say: certainly not

"Religion can be continued in, or as, painting." Perhaps it says something about how the thought of Christ's resurrection appeared, to one painter in the middle of the 19th century, when it came to mind as a single image. It is terribly difficult to push on from here and say what has happened to the half-dozen episodes that the painting conflates, or what the painting may have done to other contemporaneous religious paintings. (Has it made them seem to be less about painting? Can the *Dead Christ and the Angels* also propose what kinds of paintings about religion might come next?)

You may or may not choose to follow this path, which I will take up again at the end of this book, but it seems unarguable to me that only "cultural habit and mental sloth"—and here it is necessary to include most of the routine identification of biblical sources in conventional art history—can account for the impression that Manet's painting is *not* problematic, that it doesn't raise difficult questions of religion and painting.

I think De Duve's is the best recent attempt to think seriously about religious meaning in modernist art. Anything short of it would capitulate to easier solutions: "Faith in art is reborn out of doubt," or "Religion can be continued in, or as, painting," or "Art historical studies of Manet's sources bring us as close as we can reasonably get to what he intended." In Manet's painting *something* has happened between religion and art: the painting has not exactly contradicted religion, or quite absorbed it, or re-created it, or identified with it. The case is harder to solve than that.

With that I will turn to the body of this book: five stories of my own students and their artworks. In each case the students had the impression that they were forging their own paths across the wilderness of art and religion. I will tell the stories, and then return to each one and show how the students were not creating new configurations of art and religion, but rehearsing ideas that were defined long before them. Taken together, the five students and their artworks exemplify the major possibilities for contemporary art and religion. Each approach has its limitations, and each reflects something of the troubled relation De Duve has tried to articulate.

Five Stories

THE SCHOOL OF THE ART INSTITUTE IN CHICAGO is one of America's largest art schools, and we are committed to the newest art. Students don't apply to our programs if their art is old-fashioned or conservative. The admissions committees for the big departments, such as Painting, Film, Video and New Media, and Sculptural Practices, wouldn't normally admit a student who wasn't savvy about Andres Serrano's *Piss Christ* or Jeff Koons's pornographic photos.

Yet we do have religious students, and there is even a Christian student's association. Those students do not often make openly religious art; either they find ways to reconcile contemporary art with their religious beliefs, or else they apply only to more practical departments like Historical Preservation, Visual Communication, or Fashion, where they can keep their religious art more or less to themselves while they learn practical skills.

Kim

A few students each year try to make openly religious work—very few, perhaps two or three out of two thousand. In my experience they find that it is better not to bring their religious work to class, especially in graduate school. Our teachers are not prejudiced, but the religious content of religious art just does not get critiqued. The work's religious meaning is ignored or written off as something so personal it cannot be addressed. So the few really religious students make some work expressly for their classes and keep their religious work separate and secret.

Because I am an art history teacher and not a studio instructor, I sometimes see the secret pictures that are not shown to studio instructors. My first story is about Kim, a Korean student who made large abstract silk

screens and lithographs. One afternoon she asked if I would like to see her "real" work.

This was in the Printmaking Department, late on a Sunday afternoon when no one was around. She brought out a silk-screened image, about two feet high and a foot wide. It had the commercial-blue look of a blueprint.

At the bottom was the planet Earth, and above it the deep bluish-black of outer space. On the Earth Kim had painted a hundred small figures stretching their arms up into space. Their hands were enlarged and their bodies shrunk so that the planet looked like a curled-up hedgehog. All their palms were up, as in prayer, but with the hands apart.

At the top of the picture was a glowing sphere, printed flat white, with one enormous hand reaching down toward the Earth.

Kim was shy, and her English was not good.

"Is this okay?" she asked.

At first I did not want to say anything about the planet full of praying figures and the big UFO with its dangling hand. "It's a really beautiful print," I offered. "The blue is lovely."

"Is the hand good?" she asked.

"Yes, and it's also drawn extremely well."

Our Korean students often have superior drawing skills. Thanks to a national system of examinations that is based on 19th-century academic art, they can draw rings around most American and European students, and they often know it; but they also tend to feel uncomfortable about their skill, because they have come to realize that many of the Western students don't really care. Kim's big heavenly hand was straight out of Leonardo.

"Is the subject good?" she asked. Now there was no avoiding it.

"Well, for you, it's perfect," I said, "but I agree that you should not show it to your studio teachers. They would not understand."

She nodded. "Why not?"

Kim was in a class of mine on the subject of postmodernism. It was clear that she could not really follow the readings, although she tried. I knew she hadn't been following the classroom discussion.

"Well, in the terms we have been discussing in class, this would be kitsch, or people would just say it is too sentimental."

Kim didn't say anything. I wondered if she had understood the concepts of kitsch or sentimentality.

"I think sentiment is wonderful," she said. "It is about feeling and emotion."

She showed me a lithograph, which she had made for a beginning lithography course. It showed a cartoon fish happily swimming in cartoon

waves. A sun shone in the sky. Little lines radiated from the sun. Three cliché clouds accompanied the sun, each one flat on the bottom and puffy on top.

"This is a self-portrait," she said.

"That can't be a self-portrait—it's too happy."

I studied the picture, looking for signs that would show it was a self-portrait. The fish was like ones that very small children draw: a teardrop shape, one fin above and one below, a big round eye, and a smiling mouth that ended in a little crease like a parenthesis.

"I *am* happy."

"Are you *always* happy? Aren't you sad sometimes, or maybe a little confused?"

"Not in my art."

I decided to pursue the point. "Remember in class how we talked about ambiguity and complexity and how postmodern art is often very difficult?"

"Yes," Kim said, and like a good student she named the authors we had been reading: "I read the Roland Barthes, Clement Greenberg, and Michel Foucault. I understand their ideas. But I am happy like this fish."

It was time to quit.

"I guess I would say that if you want to make art for yourself, then this is wonderful work. But if you want to exhibit it in the West, or if you're interested in making contemporary art, then you can't make sentimental, happy work like this. And as you know, you can't make religious art, at least not art that is really obviously religious like this."

"Why not?"

From Kim's point of view, ideas like complexity, ambiguity, difficulty, the absence of religion, and lack of sentiment were just the ideas of Western art criticism and it should be possible to make first-rate art that is both religious and optimistic. I could not find the words to tell her that complexity and the rest *are* postmodernism, that they *are* contemporary art.

"Modernism is just like that." It was all I could manage.

Rehema

Like many boys my age, I once had a belt embroidered with beads, which was sold as authentic Indian art. The fact that my parents had two 19th-century Plains Indian beadwork garments, professionally mounted in double-glass metal frames, did not concern me—at that age, I thought the belt represented the kinds of Indians I saw on TV, and when I wore it I felt like Tonto.

That association did not help me when Rehema, a graduate student in the Fiber Art Department, took me on a tour of her studio. She made sculptures covered with beadwork. She showed me a set of small jewelry boxes that she had entirely covered in beads. Inside were tiny objects: little figurines, miniature photographs with embroidered borders. Rehema also "painted" with beads, and her large work that winter was an icon—a stretched canvas the size of a Russian icon, with a peaked top. She had sketched the so-called Venus of Willendorf in the middle, where the saint's image would have been, and she was in the process of "painting" it by sewing colored beads. The portion she had finished looked like a mosaic. Gold beads in the background reminded me of gold leaf, and brown beads around the edges were reminiscent of a wooden frame. The "Venus" herself was done in brilliant magentas and oranges.

Rehema was a middle-aged woman, 30 years older than most of her fellow students, and she had very strongly formed ideas about her art.

"This is the icon of femininity," she said. "I am making this piece for myself and for my friends."

I asked her what artists she had been looking at.

"Not so much artists, but writers." She pointed to her bookshelf, which had several dozen books, more than normal for a graduate painting studio. I noticed several books by Carlos Castaneda and one by Joseph Campbell.

"Where did you get the idea to do this in beadwork?" I asked. I thought she might have seen some of Lucas Samaras's bead-covered boxes.

"My fiber arts teacher suggested it, in a class exercise. After I read Linda Nochlin's 'Why Have There Been No Great Woman Artists?' I didn't want to paint in the usual way."

"And how did you choose the Venus of Willendorf?"

"I found her in a book on prehistoric Europe. I've been reading about prehistoric life. The Venus figurines were part of a matriarchy, they were goddesses who existed before the male gods, before Odin and Thor and the Celtic gods."

I wondered how to ask why she had chosen a Russian icon frame for a prehistoric image, but Rehema had gone to the other side of the studio and pulled an x-ray out of a folder. She held it up to the light so I could see.

"This is my breast," she said, and I saw where a technician had written her name up in the corner. "I was going in for a mammogram, and I asked to keep it. I think it can be another icon."

Those first years in art school, I learned more from the students than they learned from me. Rehema loaned me several books to read, by

authors I hadn't heard of—books about the goddesses of Old Europe, and about the importance of women's symbols and women's art. Back then I would never have dared ask why she mixed Russian Orthodoxy with feminist prehistory, or if she planned on putting her icon on an altar.

Brian

Brian draped himself in a chair in my office. He had a night job as the manager of a club, and whatever energy was left went into his classes in the art school. He was wearing a tight indigo T-shirt, black pants, black shoes the size of Frankenstein's, and cheap red socks: one of the half-dozen standard art world uniforms.

"I've been doing big photos lately," he said.

I looked to see if he had brought a portfolio.

"I left them out in the hall. They were too big to bring in."

We walked out to the waiting room, where he had put a roll of enormous Cibachromes. I held on to the roll while he unfurled it, revealing one of the photos foot by foot. The colors and the detail were astonishing—a sign of expensive film and paper.

"It's gorgeous," I said. "These pictures must have cost a fortune."

"Six hundred dollars each, and three hundred for the ones that are only six feet long. I took them with an 8×10 plate camera, so the detail could stand the blowup."

The pictures nearly filled the department's waiting room. When the first one was fully unrolled, I had to stand in a narrow space between it and the waiting room chairs. It was a picture of Elvis, on the cross.

"A friend modeled it for me, he's a professional model," Brian said, as if that would reassure me. The Elvis wore a loincloth and was surrounded by dangling ribbons, colored plastic sheets, and torn pieces of aluminum foil. Christmas lights sparkled through layers of iridescent Mylar. Elvis looked like he was in the middle of "Heartbreak Hotel."

The next picture was a woman posing as Madonna—as the singer Madonna, and also the original Madonna. In her lap was a teddy bear with its eyes closed. The image gleamed with garish purples, reds, and yellows. One ribbon was stamped with swastikas.

"It's a *Pietà*," I said.

"This I did with the plate back tilted down, so I could keep the whole image in focus. See the distortion?"

The Madonna was leaning back at a steep angle, but her entire body was in brilliant focus. Brian had adopted the same technique Ansel Adams

used to photograph alpine meadows, in order to keep a whole plain of flowers in focus at once.

I knew I wouldn't get anywhere talking about the Christs and Madonnas, but I tried anyway.

"What kinds of reactions have you gotten? Has anyone been offended by these?"

"Well," Brian said, pausing either from general exhaustion or because he was thinking, "one guy was interested in my camera, just because it's so expensive. Also the Mylar, they wanted to know where I got it."

He braced one arm against a wall. "I think for the next set I'm going to just do Mylar. I love the sort of weird oranges and blues you get, especially when you mix fluorescent and stage lights."

I could see there wasn't much point in talking about religion, or ideas of any sort. Brian was clearly tired. He began to roll up the photos.

That happened to me soon after I started teaching at the School of the Art Institute in Chicago. If you are not in the art world, you might be surprised that an artist can make antireligious art without ever being against religion, or even giving it a second thought. But religion fits so poorly with art that just about anything can happen.

Brian went on to photograph nude models, and his pictures became even larger and more explicit. The last photographs I saw were very sharp and sexual. He loved talking about those. They were good enough to be shown in a gallery, and they had no trace of religion.

Ria

My fourth story is about Ria, a student in the Sculpture Department who invited me see her ceramic sculpture of the 14 Stations of the Cross. In Catholicism, the Stations are traditionally defined moments on Jesus' walk to Calvary. Usually they are represented by paintings and plaques inside churches, and worshipers walk around, pausing at each Station. Some churches maintain outdoor paths where each Station is represented by a sculptural group. I couldn't imagine what a sculpture of all 14 Stations would look like.

Ria's artwork turned out to be a large ceramic church, about two and a half feet high. She had molded the clay by hand, and the house was wobbly like half-melted gelatin. It was a big gangly pile, and it reminded me of a Victorian mansion with corner turrets, gables, and wrap-around porches. She had poured gray and white glaze over the whole thing, and the glaze had dripped down like sugar frosting on an angel food cake. I

walked around it, peering in the little doors and windows. I couldn't see the 14 Stations anywhere.

"I erased them," she said.

I looked into an upper-story window. The fired clay on the floor inside was bumpy, as if something had been cut or torn out of it.

"So you used to have little sculpted figures inside?"

"And also labels, all the usual stuff."

"Where were the labels?"

"On the outside. Now they're buried under the glazing."

"So now," I suggested, "it's really not a representation of the 14 Stations. It's like a large confectionery house, a sugarplum fairy's house."

Ria didn't like that. "Well, to me it's the 14 Stations."

"Do you come from a Catholic family?" I asked, even though I already knew the answer.

"Yes, my mother is very pious. I just don't believe in all that anymore—the robes, the priests, the church, the idea that the pope is always right."

"So the 14 Stations ... "

"There is just something about them, I don't know. I want the feeling, something about it."

"And now almost nothing is left."

"I hope it is the real part."

I thought: real ceramic ooze, real mud and water, no men in long black robes.

She had piously extracted the religious symbols from her work, hoping the residue would keep what she really cared about.

Joel

When I visited Joel's studio in the Painting Department, the walls were full of pictures of a heart-shaped object. It looked like a cross between a Valentine's Day heart and a ceramic jug, or like a simplified anatomical diagram with one looping vessel at the left and another, cut off, at the top.

I asked where he had gotten the idea.

"I don't know, I just started drawing them last year." Joel was diffident. He wore his hair tousled and he had a thin teenager's beard.

"Is it a heart, basically?"

"Basically, but it means a lot of things." He picked up a notebook and opened to a page full of symbols. He handed it to me and I thumbed through it. The pages were filled with symbols and notes. It looked more

like a scientist's notebook than an artist's sketchbook.

I came to a page where the symbols were arranged in a table. "Last year I was in a Jungian dream analysis group," he said.

I handed the book back and he turned to the end, where the heart-shaped symbol was repeated over and over with slight variations. "They told us to write down all the things we saw in our dreams, and this shape was one of them."

On one wall of the studio Joel had tacked up 50 or 75 pencil drawings, each representing a heart or several hearts. Some of the heart shapes were elongated, others squat. One drawing was stippled, like Georges Seurat's moody drawings of Parisians. Another was executed using a soft pencil in jagged zigzag marks, as if he were practicing the style of German expressionism. On the back wall he had hung pictures done in oil crayons, on prepared particleboard. They were thicker, greasy, and colorful, with smeared indistinct backgrounds. They were clearly all versions of the same shape.

He had nailed up small pieces of wood, which served as shelves to hold little ceramic versions of the heart shape. Like the painted hearts, the sculpted ones were succulent, shiny, and full.

"Have you looked at Jim Dine?" I asked. Dine's hearts are probably the most famous examples of the shape.

"I've seen them."

"Did your Jungian group tell you what the shapes mean to you?"

"I'm not in that group anymore. I don't know really what they mean. I just know I want to work with them some more."

"What do you think they mean? Do you have some ideas about what they might mean?"

"Well, the heart is a universal sign of love and fidelity, and feelings." He sounded uncertain and bored, like a student in a language class reciting a verb paradigm. "Some are a little like mechanical hearts ... " he trailed off.

"So they are not really about love?"

"Yeah, I don't know."

I wondered if he really cared about what he was doing. In art school it is not uncommon to find students who stick to one kind of art even though they don't care very deeply about it.

"The thing is, I love drawing this shape. I think about it a lot, but I don't really like to talk about it."

That sounded sincere and a little embarrassed. I walked around the studio. By the doorway he had thumb-tacked postcards with paintings by Chardin, the midcentury English artist Ben Nicholson, and the nearly

abstract still-life painter Giorgio Morandi. A backpack in one corner was open and inside was a half-eaten sandwich. The floor was scattered with crumpled papers and shreds of sharpened oil crayons. Clearly this was his life.

"So they have a kind of private meaning," I said, "even though you have not discovered what it is."

"Yes, to me."

"And it is not Jungian."

"I am out of that group now."

"But the meaning isn't really related to work by people like Dine, or Morandi, or Chardin?"

"It is, I mean I hope it is, but probably not."

Joel kept making paintings and sculptures of his heart motif until he graduated. I haven't heard from him since, but I suspect he has not gone on in art. His work was too personal, not sufficiently connected to contemporary art. He seemed to care whether his pictures were good, but I wonder if the criticism he got at the school really mattered to him. What mattered was the heart shape, and it mattered that no one could tell him what it was.

I am going to take the rest of this book to explore and explain Brian's, Kim's, Rehema's, Ria's, and Joel's ideas. They represent the five main approaches to the problem of making religious art. In a nutshell:

> Kɪᴍ: conventional religious art.
>
> Bʀɪᴀɴ: art that is critical of religion.
>
> Rᴇʜᴇᴍᴀ: art that sets out to create a new faith.
>
> Rɪᴀ: art that burns away what is false in religion.
>
> Joᴇʟ: art that creates a new faith, but unconsciously.

I think that I can demonstrate that virtually all attempts to combine art and religion, at least since the end of international modernism around 1945, fall into one of these five categories. Each of the five has a history, strengths, and weaknesses—and each one goes to prove my pessimistic point that it is nearly impossible to mix art and religion.

Kim's Story Explained:
The End of Religious Art

KIM, THE STUDENT WHO MADE THE BLUE LITHOGRAPH WITH GOD'S saving hand, was a religious artist. For her religion came first: she was a Methodist, and she understood that world much better than she understood contemporary art. The work she showed me could have been hung in a church, behind the scenes or even behind the altar. (Kim may have gone on to work for churches. I have had other students like her who made paintings and stained glass windows for churches.)

I told Kim that her kind of art might not get good reviews from the faculty. It would have been more honest to say that she should probably leave the school as soon as she had learned to make silk screens and lithographs. Sincere religious art like Kim's has no place in the art world.

On the other hand, religious art is ubiquitous outside the art world, and modern religious artworks hugely outnumber modernist artworks. A friend of mine, the art historian David Morgan, has made a special study of popular religious imagery in 20th-century America. He says that one of the most popular pictures of the 20th century—far more widely reproduced than anything by Picasso or Pollock—is the backlit Jesus with the flowing blond hair, painted by Warner Sallman in the 1940s (see figure 11).[1] Once I read Morgan's account of it, I started seeing it everywhere. A television talk show called *Late Night with Conan O'Brien* did a skit in which Sallman's picture was modified so Jesus appeared first as Elvis, then as a girl, and finally as an African American with a 1960s-style Afro. Sallman wasn't credited by name, but he didn't have to be because the image is so widely known.[2]

On the other hand, hundreds of churches and temples display modernist artworks. The Meditation Room at the United Nations Headquarters in New York (1957) is one example among many: it's a small trapezoidal room with a polished iron altar, lit from above with a cold blue light. Beyond the altar is a generic-looking cubist abstraction by an

Fig. 11. Warner Sallman, *Head of Christ*. 1940. Anderson University.

artist named Bo Beskow. The United Nations Secretary-General Dag Hammarskjöld, who helped the architect Wallace Harrison design the room, said that he hoped he "could perhaps virtually do without symbols," and even "achieve an absolute purity of line and color."

The Meditation Room was an important and well-publicized precedent, and so it is interesting that the artist, Beskow, is relatively obscure. Aside from Matisse's chapel in Vence there are only a few other churches decorated by well-known 20th-century artists: Mark Rothko's interfaith Chapel in Houston, Texas (1971); Louise Nevelson's chapel in St. Peter's Lutheran Church, 54th and Lexington Avenue in New York City (1975); and Willem De Kooning's triptych in the same church (1986). Books on the subject, such as Frédéric Debuyst's *L'Art Chrétien contemporain* (1988), name a half-dozen others, but the list quickly gets obscure. Debuyst mentions Matisse and Chagall, illustrating a Chagall window in the Hadassah Medical Organization in Jerusalem—but most of the artists he discusses are not that well known. A typical example is the "major contemporary artist" Alfred Manessier (1911–93), a minor follower of cubism and surrealism.[3]

It does seem that Chagall is a kind of model in his insistence on religious meaning and his interest in public commissions. Georges Rouault would be another example along those lines. A less well-studied example is Abraham Rattner, for whom painting was mainly a way of "being with God" (See figure 12).[4] His *Study for a Crucifixion* is typical of a kind of work that is widespread in Christian churches in North America and Europe: it is a weakened version of German expressionism, with a cubist twist. The painting's style is clearly midcentury modernist in tenor, but not too obtrusively artistic. The German painter Hans Fronius is another instance of the admixture of dilute expressionism put in the service of religious content.[5] He is probably at the outer limits of what was acceptable to midcentury congregations, and most of his works are in private collections. His *Pietà* (1965) is haggard and heartfelt and not a very good painting by fine-art standards (see figure 13). Fronius and his admirers are quite thoughtful about the obstacles to making religious painting and the problems of bringing explicitly religious themes into contemporary art; but that sensitivity has not helped Fronius gain an audience in the art world.[6] Another serious defender of modernist religious art is John Dillenberger, whose *Visual Arts and Christianity in America* is an ambitious survey of religious painting, spanning nearly three centuries. Significantly it contains very little art that is also in art historical textbooks, museums, or galleries.[7] Other books, such as Kathleen Regier's *Spiritual*

Fig. 12. Abraham Rattner, *Study for a Crucifixion*. 1950. Des Moines Art Center 1952.1

Image in Modern Art (1987), pick their artists carefully to include those who are on record saying they are involved in religion.[8]

One of the best-known religious writers who was also interested in modern art was the Protestant theologian Paul Tillich. He admired German expressionist painting, and when he was working in Berlin in 1919–24 he used paintings by the expressionists Emil Nolde, Ernst Heckel, and Karl Schmidt-Rottluff to illustrate how art can have spiritual value. For Tillich, expressionist painting was the best "mediator of the ultimate reality." Tillich was adventurous to be teaching the German expressionists in those years, while there were "fist fights going on the opposite side of the street" between the advocates of the new avant-garde and the bourgeois defenders of older art, some of whom were soon to become advocates of Nazism.[9] But Tillich's writing on the subject is also

Fig. 13. Hans Fronius, *Pietà*. 1956. From Existenz und Rückbindung: Zum religiösen Werk von Hans Fronius (Linz: Landesgalerie Oberösterreich), 109.

poignant because the representation of "ultimate reality" has almost nothing to do with the reasons why Schmidt-Rottluff and Heckel are valued in art history and kept in art museums. It isn't their potential significance as religious artists, but their intransigent rebellion against many institutions, organized religion among them, that matters when it comes to their place in history.

I am trying to suggest two things at once: that popular religious art is a widespread phenomenon, and that it is extremely difficult to claim that such art has a place in the history of modernism and postmodernism. Even the list of chapels I gave above is problematic. St. Peter's Lutheran Church is known for its patronage of contemporary art; it also has a dossal curtain woven by the fiber artist Ann Bromberg, a crucifix by Kiki Smith, and a piece of blown art glass by Dale Chihuly. (The religious value of some of those works is open to question; Chihuly's work also decorates the foyer of the Bellagio in Las Vegas.) St. Peter's Lutheran is hardly an ordinary church. The Rothko Chapel is not an ordinary chapel at all—it has no altar and is not consecrated to any one religion.[10] In fact few modernist painters and sculptors took on church commissions, and those that did tended to practice watered-down versions of modernist styles. A certain quotient of cubism or expressionism might be acceptable to a com-

missioning body or a congregation, but if the modernist content became too strong the work might not be perceived as viably religious. Few tried, and those who succeeded practiced compromised styles.

There is a problem here for the major religions. Why does a pallid late-expressionist style do duty for art in churches and temples? The issue is not complex: it can be stated as Von Ogden Vogt does in a book called *Art and Religion,* published 80 years ago. "A spiritual movement," he says, "that does not find expression in the arts cannot attain self-consciousness or dominance or survival."[11] Vogt is a bit histrionic and more than a little historicist, but from an art-world perspective it is difficult to disagree about what is being expressed by the belated echoes of modernism in churches and temples. Because I work in the art world, I feel uncomfortable when I am asked to comment on art in churches that has just a pinch of modernism in it, especially when the artist was emulating art that was already conservative in 1950. Even the best cubo-expressionist religious painting cannot compete with current expressionisms in the art world. Fronius's pictures follow a kind of expressionism that belongs to the first half of the 20th century, though it lingered on after 1945, mostly in Paris. If Fronius's kind of expressionism is too strong for use in churches, then it is hard to see how there is much hope for religious painters inspired by more recent revivals of expressionism, from 1980s neoexpressionism to contemporary global expressionisms. Religious art destined for churches and temples remains marginal and uninteresting by art-world standards.

There are, on the other hand, no lack of competitions and exhibitions on the subject of religious art in the art world. In 1990, I was one of four jurors for an exhibition called "Revelations: Artists Look at Religions."[12] It was a large show: we had 10 or 15 pieces by well-known artists, including Mike and Doug Starn's *Christ* (1985–87), Andres Serrano's *Madonna and Child II* (1988), and Joel-Peter Witkin's *God's Earth and Heaven, New Mexico* (1988, figure 14). The other jurors were artists; I was the only historian. For two days the four of us looked at slides sent in by artists who wanted to be included. All day long, nine to five, we watched slides go by. We skimmed hundreds of artists' résumés, we tried to decipher their written statements, and we watched films and videos of performance art.

Most of the submissions were like Joel's and Ria's work: enigmatic and personal, and clearly sincere. We accepted a fair number of those pieces, enough to fill several rooms in the gallery. Some of the artists submitted antireligious work. The three other jurors especially loved a little plastic crucifix under which the artist had glued a sign reading "BEAM ME UP SCOTTY." I laughed when I saw it, but the joke didn't last long and the

Fig.14. Joel-Peter Witkin, *God's Earth and Heaven*, New Mexico. 1988.
Photo: Fraenkel Gallery, San Francisco.

work was not very good. (The work was reminiscent of the Argentine
artist León Ferrari's *Western, Christian Civilization,* illustrated in figure
15: it's a very strong one-liner, and if it works, it works without asking
to be seen again or considered in depth.)

So we had privately spiritual work, like Joel's heart shapes, and more
or less antireligious work, like Brian's iridescent Elvis photographs, and
in-between work, like Ria's ceramic house of the 14 Stations. There were
also a few artists who identified themselves as religious people. One had
painted a crystal palace, tall and gleaming like the outside of Emerald
City in *The Wizard of Oz.* A dove was flying in the spacious interior, like
a pigeon lost in a Gothic cathedral. One of the other judges liked the pic-
ture, because it seemed to be intentionally quirky, like a pastiche of a cover

Fig.15. León Ferrari, *The Western Christian Civilization (La civilización occidental y christiana)*. 1964. Collection of the artist. Reproduced in Arte en Américe latina (Buenos Aires: MALBA, n.d., c. 1999), 68–69.

from an old church publication. We were about to accept it when someone read the artist's statement: it turned out the artist was a nun, and this was her vision of Heaven.

"Oh, God," one of the judges said, and they voted it down. I wanted to accept it because it was religious, and religion was supposedly our theme. I was outvoted three to one.

Another artist submitted slides of her paintings of leaves, big and succulent like Georgia O'Keeffe's. Again we liked the paintings, but the artist's statement began, "I am a monk in a closed order in Lancaster, Pennsylvania. These pictures are my meditation on God ... " I don't remember the rest, but that was enough. The other judges rejected the monk's work because it was too sincere.

The only religious work we accepted into the show was an abstract circular pattern done by a Native American. It was a religious symbol of some sort, perhaps related to a Navajo *ikaah* (sand painting) but the artist didn't say. We accepted it, I think, because we didn't know what the religion was. To us, it was an abstract painting.

In the entire show of almost a hundred pieces, none were made by practitioners of major religions. Kim's silkscreen would not have made the cut. At the end of the judging we decided to add some non-Western religious works, including several 18th-century Hindu Shiva lingams, horse skulls from the Ibo tribe in Nigeria, and a hunter's fetish coat and hat from Mali. Those seemed acceptable because they represented religions no one knew very well—they could be enjoyed privately, as spiritual objects.

That experience was what started me thinking about the exclusion of religious meaning in contemporary art. The art world can accept a wide range of "religious" art by people who hate religion, by people who are deeply uncertain about it, by the disgruntled and the disaffected and the skeptical, but there is no place for artists who express straightforward, ordinarily religious faith. To fit in the art world, work with a religious theme has to fulfill several criteria. It has to demonstrate the artist has second thoughts about religion, and the religious ideas have to be woven into the work, because otherwise it looks as if art is playing propagandist for religion. It also has to appear that the artist is meditative and uncertain about both art and religion: ambiguity and self-critique have to be integral to the work. And it follows that irony must pervade the art, must be the air it breathes. Kim's work would also have been unacceptable because it was sincere, sweet, sentimental, and naïve, not to mention openly pious. The mistrust of trust is unfortunate, I think, because sweetness and sincerity can be intriguing, as Jeff Koons shows. But the

interest in irony, ambiguity, and uncertainty is not—this is the crucial point—a superficial proclivity that can be altered by reorienting the politics or the faith of the art world. The excision of piety and faith from art has deep roots and is entangled with the very ideas of modernism and postmodernism.

The Russian artist Olga Tobreluts (b. 1970) is an interesting example. She uses computers to put movie stars' faces into Renaissance paintings.[13] She took Antonello da Messina's painting of *St. Sebastian* and gave the saint Leonardo di Caprio's head. In the background, Antonello had painted a piazza lit with the crystal-clear afternoon light that 15th-century Italian painters did so well; Tobreluts decorated the buildings with posters of Karl Lagerfeld and Jack Nicholson. Tobreluts is a member of a movement called Neo-Academism, founded by an artist named Tibor Nomikov. The Neo-Academics follow a Russian line of thought, believing the West has turned its back on real spirituality. They are not so much making fun of capitalism and consumerism as they are transplanting it, moving it back five centuries to its premodern beginnings. Neo-Academic pictures are a little funny, and they can end up looking a bit like Koons or Warhol, but they have a serious purpose. "Today nothing is more radical," Tobreluts writes, "than painting religious scenes, oil on canvas, with no postmodernist humor."[14] Her picture of Kate Moss shows her purpose very well (figure 16). It is also taken from one of Antonello's paintings, the extremely beautiful portrait of *Maria Annunziata,* now in the Museo Nazionale in Palermo. Antonello's painting is as simple as it can be: Mary's lectern is turned slightly, impeccably cast into perspective. Her raised hand unobtrusively shows the painter's skill. The image concentrates the viewer's attention on Mary's face, and so does Tobreluts's version. There is almost no difference between Antonello's original and Tobreluts's appropriation, except that hers is printed on watercolor paper instead of painted on panel, and Tobreluts has put Kate Moss's face in place of the Virgin's. Tobreluts's picture does not work as contemporary art, or even pop, and it is not intended to. Neo-Academism does not fit with current art because it is too sentimental and serious.

Kim's work might be considered perfectly good as printmaking, but it belongs to a moribund strain of visual art that is cut off from what is interesting about current practice. It is a simpler and less challenging activity than what is now called painting or printmaking. As the German philosopher Georg Wilhelm Friedrich Hegel wrote at the beginning of the 19th century: "it is no help to adopt again ... past world-views."[15]

Fig.16. Olga Tobreluts, Kate Moss from the series Sacred Figures. 1989. *From Heaven*, edited by Doreet Levitte Harten, 186–89. Courtesy Art Kiosk and Foundation, Brussels.

Rehema's Story Explained:
The Creation of New Faiths

IT MAY SEEM I AM BEING TOO STRICT. Perhaps there is a problem mixing contemporary art with established religions like Methodism or Catholicism, but newer faiths might mingle more easily. As I learned in the years after I met Rehema, the student who made the beadwork Venus, there are almost as many new faiths in the art world as there are artists.

Michael York's book *The Emerging Network*, one of the best guides to the subject, lists dozens of faiths.[1] Here are some, just for the flavor of hearing so many new and old names all together: neopaganism, animism, Nordic paganism, spiritual alchemy, the Covenant of Unitarian Universality Pagans, the Arcane School, World Goodwill, the Pagan Circle Alliance, the Circle Network, Odinism, the Ancient Wisdom Tradition, New Thought, Spiritualism, the Urantia Foundation, the Arcane School, the Church Universal and Triumphant, Scientology, the Process Church of the Final Judgment, the Human Potential Movement, Synanon, Erhard Seminar Training, transcendental meditation, the Rajneesh Foundation International, the Siddha Yoga Dham of America, the Johannine Daist Community, the Krishnamurti Foundation, tantric yoga, the Arica Institute, the Friends of Meher Baba.

Collectively, inaccurately, the new faiths tend to be called New Age. York calls them NRMs: new religious movements. Many are branches of Islam, Hinduism, and other established faiths. Others are sui generis. Some descend from Renaissance and 18th-century faiths such as Ficinian neo-Platonism, Isaac Luria's kabbalah, hasidism, or Egyptophile cults that have been present in Western civilization since the fifth century.[2] Others derive from the late Roman Empire, and especially from neo-Platonism, neo-Pythagoreanism, and Alexandrian Hermeticisim (a faith that is still popular in its current guise as spiritual alchemy).[3] Still others are a mixture of *fin-de-siècle* revivals of magic, including Victorian practices of witchcraft, revivals of medieval magic, and kabbalist magic. Generally

speaking, the NRMs are unrelated to one another except by the coincidence that they all began or were thriving at the end of the 20th century.

The *fin-de-siècle* at the end of the 19th century also inspired a flux of mystical faiths, from theosophy to occultism; but the *fin-de-millénnium* faiths at the end of the 20th century, which I have just sampled, are significantly more diverse. In the art world totemism, reliquation (the worship of relics and reliquaries), the Wiccan religion, Egyptophile cults, Celtic Christianity, and even Satanism are blended with astrology, palmistry, animism, Santería, and herbal alchemy. During my first few months teaching at the School of the Art Institute, I was surprised to see the department secretary on Chicago television, performing a Wiccan ceremony. Since then I've become accustomed to the proliferation of new faiths: it is a fixture in the art world.

Rehema's faith had no name, or none she ever told me. I became acquainted with her concerns by reading what she read, especially Marija Gimbutas's books on the matriarchal, proto-feminist Old Europe, and Georges Dumézil's speculative studies of ancient Indo-European culture. Rehema was interested in Carl Jung and convinced by his follower and popularizer Joseph Campbell. (Jung is hardly cited in literary theory or in university art departments, but he is widely influential in art schools and among practicing artists. The difference between the art studied in universities and the wider world of art practices can almost be defined by the acceptance, or rejection, of Jung. Inside academia scholars make use of Lacan and other post-Freudians; outside it, and in studio practice, people read Jung and Joseph Campbell.)[4] Rehema also read an eclectic selection of feminists including Suzi Gablik, Hélène Cixous, and Luce Iragaray. She found the books through friends rather than classes, and she used them to build her own sense of faith and community. The "Venus" done in beads was an experimental icon—a religious test piece, an attempt to make a viable spiritual image. I do not know if Rehema ever embroidered her mammogram, but I don't doubt that mammograms have been used as spiritual images, because I have met several student artists who incorporated their mammograms into their art. The closest example I know is an altar image of a picture of a living heart, made by the artist Kathy Vargas for a friend who had suffered a heart attack.[5]

In my experience, artists who practice the new faiths tend to be interested in contemporary fine art, at least more so than professional artists whose work is commissioned for churches and religious patrons. But artists involved in the new faiths also tend to be excluded from the gallery scene even more strictly than artists whose work expresses Catholic, Jewish, or Protestant meanings. It could be that gallerists and curators

sense an affinity—the new faiths may seem a little closer to what they already offer.

The very few academics who consider such art are treated skeptically by the profession.[6] The anthropologist Marilyn Houlberg is an expert on Voudoun and Santería (the Caribbean synthetic faith, comprised of Catholic and African elements), and she also has a large collection of Elvis memorabilia, including—as she is proud to say—the only certified weeping Elvis painting in the Midwest. Houlberg wears different hats depending on the occasion: when it's a show of Haitian religions, she appears as an anthropologist. When it's an exhibition of Elvis memorabilia, she puts on the campy art-world hat and becomes a priestess of the Elvis cult. Houlberg is elusive about her own beliefs. She knows her Elvis painting doesn't really cry, although its mechanism is top secret. But she lives with her passions, whether they are Elvis or Santería, and she takes part in Haitian and African rituals instead of standing back like a good anthropologist. There is no clear way to speak about her use of images: it's not normal anthropology, and it's not quite art.[7]

Another example is the art historian Suzi Gablik, one of the rare advocates of spiritual values in contemporary art. She finds spiritual meaning in many modern and postmodern artists by linking their work to an "alternate mode of consciousness" that she describes as "man's inclination toward the mythic and supernatural."[8] She has been a forceful advocate for prehistoric, ecological, and feminist values. "Numinosity runs through" Gilah Yelin Hirsch's nature paintings, Gablik says, "like fire in a fire-opal. You feel it in the glisten of fermented light, dancing like burnished copper through the trees . . . "[9]

Art historians, for several reasons, have not greeted Gablik's approach favorably. Her stress on what she calls "re-enchantment" seems to make sense when it comes to artists like James Turrell, Richard Long, or Andy Goldsworthy, who create poetic objects in natural settings, but it fits other work less well. Nor is it clear that Gablik's villains form a coherent group: they include the philosophers Jean-François Lyotard and Jean Baudrillard, the painters David Salle and Peter Halley, the photographers Barbara Kruger and Sherrie Levine, and Jeff Koons. Gablik's approach can look too easy, as if nearly anything could be said to have a spiritual aura if it is seen from the right angle.

Like my student Rehema, Gablik draws on archaeological theories, some of them discredited within archaeology, which propose that a kind of shamanistic religion was practiced in relation to the first European cave paintings.[10] The idea of a peaceful, feminist or nonandrocentric culture in neolithic Europe, first proposed by Robert Graves and hugely

elaborated by Marija Gimbutas, remains very popular at the beginning of the 21st century, and it is represented in a number of books.[11] Recently the idea of a matriarchal Old European culture has also been fueled by the ongoing Celtic revival in Ireland and England.[12] This is despite the fact that Gimbutas's ideas have been effectively challenged within archaeology.[13]

In a sense Gimbutas and writers influenced by her are part of an even larger phenomenon, the 20th-century valorization of the primitive. "Brancusi's attitude towards stone," Mircea Eliade claimed in *Art, Creativity, and the Sacred,* is "comparable to the solicitude, the fear, and the veneration addressed by a Neolithic man toward certain stones that constituted hierophanies—that is to say, that revealed simultaneously the sacred and ultimate, irreducible reality." Like his "Carpathian ancestors," like "all Neolithic men," Brancusi "sensed a presence in the rock, a power, an 'intention' that one can only call 'sacred.'"[14] Maybe, but it is also possible that Eliade and Brancusi (who shared some of Eliade's ideas) were projecting their own thoughts back onto practices whose meanings are wholly lost. How much sense does it make to use words like "hierophanies" or even "sacred" to describe attitudes people might have had toward a rock 15 thousand years ago—people who might not even have had language, not to mention religion?

It does not necessarily matter if a work of visual art is made possible by a collection of dubious theories. (There is no end to great art made by artists who had ridiculous and misinformed theories.) What does matter is that art inspired by NRMs, or even by scholars such as Gimbutas and Eliade, tends to have a loose relation to the art world. Mary Nelson, author of one of the best surveys of current American spiritual and New Age painting, says her book is "a record of the events, almost entirely mental and emotional, that transformed the lives of people." She is not interested in art alone or art for art's sake, and certainly not in the avant-garde. Her subjects are "visual artists, healers, channelers and shamans whose creative breakthroughs were fueled by upwelling changes in consciousness." The connection between artists' "metaphysical insights" and shamans' "metaphysical knowledge," she thinks, is a "gift of prophecy." "I view them all as artists," she concludes.[15] The art Nelson studies may have coherence from a spiritual point of view, but as art it is poor. It is derivative, sentimental, sometimes unskilled, often anti- or premodern, and scattered in its art-world affinities. The artists borrow from expressionism, photo-realism, Dalí, Redon, and many others as the occasion requires, and exhibitions tend to run the gamut from photo-realism to conceptual art. As one might expect from such a diverse group of faiths,

there is no one New Age or NRM style. I will consider just three examples: the first two from an exhibition held in Aspen, Colorado, in 1989, and the third from the Norwegian painter Odd Nerdrum.

Ann McCoy's large drawing called *Magna Mater* is a vast dream of a primordial mother, whose image, the artist says, has been removed "by the priests of Mithras who took over Eleusis, the fathers of the Reformation, and the soldiers of Islam" (see figure 17). In a long and poetic artist's statement McCoy conjures some of the drawing's meaning. The *magna mater,* she says,

> is not the mother of my childhood inflicting pain under duress. The goddess comes to take the mother's place, as Christ comes to relieve our suffering. . . . My dream ends in the back of the dark cave. The bears have taken me there like Dante's Virgil. An old crone lies wrapped in rabbit fur blankets. She is Corn Mother from my childhood, tiny and frail. Her hair falls like spider webs. Her eyes are covered with cataracts. I lift her up to hear her whisper. She tells me blindness is not such a bad thing . . . that one can see with the inner eye.[16]

Alex Gray's painting *Holy Fire* also represents a spiritual journey, but of a different kind (see figure 18). In the first scene, he says, "the soul-searching pilgrim arrives on the mountaintop and his inner forces of kundalini energy, the serpent power, begin to ascend." In the middle panel he is transformed in a "tantric purification rite," uniting "his dead phallus" with "the Dark Mother of time, birth, and destruction, Kali." In the third panel, "the hero is now re-assembled and comes down from the mountain to address the people." Gray's statement is also long and passionate, and he presents this and other paintings as evidence of the spiritual metamorphosis he has undergone.[17]

Odd Nerdrum is a more prominent and contested example of an artist whose themes are broadly consonant with NRMs. He paints postapocalyptic or prehistoric themes clouded by surrealist surprises (mummifications and amputations, incomprehensible implements) and made wholly opaque by a lack of consistency and his own silence about the content of his work. So far his reception has mainly been negative, but the ambiguity of his themes has probably helped gain him some notice in the art world. Nerdrum himself has tried to promote his cause by claiming he is revaluing and embracing kitsch, a move that seems historically accurate given the work's po-faced seriousness and its affinities to the mysticism and hermetic cults of *fin-de-siècle* painting. But Nerdrum does not mean kitsch

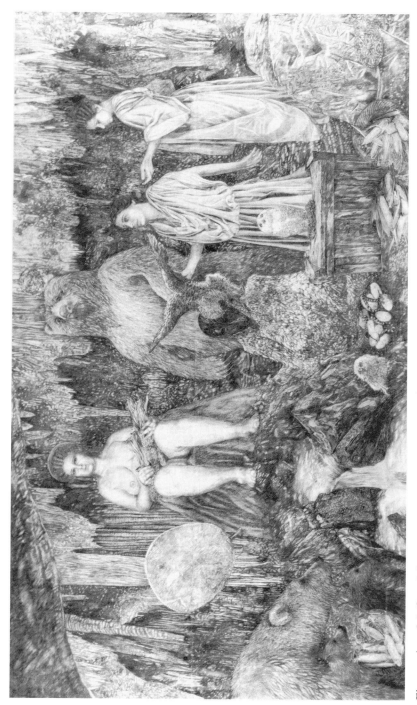

Fig.17. Ann McCoy, Magna mater. 1988. From Revelations: The Transformative Impulse in Recent Art, exh. cat., edited by David Floria (Aspen CO: Aspen Art Museum, 1989), 16.

Fig.18. Alex Gray, *Holy Fire.* 1987. From Revelations, 13.

as it is historically understood; he redefines it as something that is not art, but is dedicated to the "sublime," the "timeless," and the "eternal."[18]

Like Rehema, McCoy and Gray make pictures that function analogously to religious icons. They can look like icons or altarpieces, though they could never be put in churches. Artists associated with NRMs make artist's altars that recall traditional altars, as well as tablets, holy texts, diptychs, triptychs, polyptychs, mandalas, pseudo-kabbalistic diagrams of the sefirot, reliquaries, *sacraria* (places where reliquaries are kept), and invented ritual paraphernalia. Some of this work is allied to paintings made by outsider artists: untrained, sometimes socially outcast artists like Adolf Wölfli and Henry Darger.[19] Outsider art and related kinds of art, such as *art brut*, naïve art, and self-taught art, are taken to be more heartfelt, direct, spontaneous, and genuine than artworks by run-of-the-mill artists who are the products of academic training.[20] It is assumed to embody heartfelt beliefs and not to be tarnished by art-world irony. The art critic Roger Cardinal, who defined outsider art in 1972, makes a connection between the outsider artists' low level of technical skill and their obsessiveness. There are several historiographic and conceptual problems with outsider art and cognate concepts; for example, it is not clear whether people who have less training are apt to be more genuine or obsessive. In the present context an especially interesting problem for theories of outsider art is the existence of large numbers of artists who follow personal belief systems or NRMs. McCoy's and Gray's work is technically accomplished, so it cannot be claimed to fulfill the criterion of lack of formal training; but in other respects it fits the common criteria of outsider art: it is eccentric, iconographically idiosyncratic, heartfelt, obsessive, free of irony, and it is seldom considered as fine art. By those criteria, it should be a kind of outsider art, but it is rejected even there.

(A word, before I go on, about style. The main reason Gray's and McCoy's work is not accepted as fine art is their sincerity and openly declared beliefs. The same would be true of Nerdrum, I think, except that his beliefs are kept private. In each case, however, style does play a part. McCoy's painting is done in a richly detailed old-fashioned fine-art style that can be traced back through 20th-century fantasy art to 19th-century history painting from Paul Delaroche to Puvis de Chavannes and Gustav Klimt. Gray's painting has a faint flavor of Tibetan *tangka* painting, and seems disconnected from current forms of realism, surrealism, or neoexpressionism. Nerdrum has said his style is modeled on Rembrandt, but he owes much more to Ferdinand Hodler, Franz von Stuck, and other academic painters of the early 20th century.[21] I put these observations in parentheses because the manner of the painting, by itself, cannot account for the consistent ostracism that NRM painters experience.)

Despite its faults, outsider art is a useful category for a number of artists who make idiosyncratic religious icons and altars. One is the prophet William J. Blackmon, who has made religious objects that derive partly from graffiti and aren't suitable for churches.[22] Another is James Hampton (1909–64), whose enormous altar called *The Throne of the Third Heaven of the Nations Millenium [sic] General Assembly* is kept in the Smithsonian Institution (see figure 19). Hampton's work includes some traditional elements found in churches, such as a throne chair, an altar table, several pulpits, and offertory tables. Other objects in *The Throne of the Third Heaven* cannot be identified. Hampton made the work in his garage, using wooden furniture, tinfoil, gold foil, Kraft paper, light bulbs, plastic, cardboard, glue, upholstery tacks, nails, and straight pins. It is an altar, but not one that can be put in a church.[23]

Among contemporary artists the African American sculptor Betye Saar is probably best known for making altars (see figure 20). She has been making altars since 1973, decorating them with objects from "ritual places all over the world," as she says—mainly from Haiti, Mexico, Europe, and Africa. (She doesn't usually call them altars: instead they have names like *Rites of Passage, The Griot's Virgil*, and *House of Ancient Meaning*.) One of her altars is embellished with computer chips. Another is in the form of a canoe, in imitation of archaeological finds at the Turkish site of Çatal Hüyük. Kay Turner, author of a lovely book called *Beautiful Necessity: The Art and Meaning of Women's Altars*, quotes Saar as saying that "by shifting the point of view," mixing disparate cultures and symbols, "an inner spirit is released."[24]

Unlike Rehema's work, or McCoy's or Gray's, Saar's objects are immediately identifiable as altars. Some have stands, and some sit on the floor

Fig.19. James Hampton, *The Throne of the Third Heaven of the Nations Millenium [sic] General Assembly.* c. 1960–1974. Smithsonian Institution, Washington DC. ©Smithsonian American Art Museum, Washington DC. Photo: Alinari/Art Resource, NY.

Fig.20. Betye Saar, *Spirit Catcher*. 1976–77. Photograph courtesy of Michael Rosenfeld Gallery, LLC, New York.

or lean against the wall (as Hopi and many non-Western altars do). Many are box-shaped or made as tables, as altars are. Viewers from a range of cultures would recognize them as altars or ritual objects, and I imagine many viewers would sense that Saar's altars are invented. The question of how to worship at an altar that is also one person's private invention is already a difficult one, and it is only made tougher by the realization, in Saar's work, that the altar is also in an art gallery and has a price attached to it. When I first met Saar, I thought that the altar-in-an-art-gallery problem was insuperable, and I was unconvinced by her work. I thought people could only have half-hearted spiritual feelings in front of altars they had bought in an art gallery—their responses would be more aesthetic appreciations than prayers. Now I am more sympathetic. The sheer force of Saar's interest in "inner spirit" compels her to keep trying to make altars even if they have to be seen as art objects with prices.

Turner's book *Beautiful Necessity* documents several hundred women artists who make altars. The Chicana artist Amalia Mesa-Bains has made an altar to "the secular 'goddess' of Chicana art," Frida Kahlo; Renee Stout made an altar for fortune-tellers, with a crystal ball and Tarot cards as altarpiece panels; Barbara Ellmann made a *Flower Altar* in 1980, with the idea of centering worship on the universal offering of flowers.[25] Turner illustrates altars to lesbian life, to Aphrodite, to Barbra Streisand. Turner also writes about improvised home altars, mostly done by Hispanic women who are not artists, and she does not make much of the differences between those altars and ones made by women artists to be sold in galleries. She is an anthropologist, and her concern is the social phenomenon of women's altars, whether or not they are presented as art. Like Mary Nelson, she accepts a broad range of work as art. Turner and Nelson are examples of the wider sense of the expression *art world* that I mentioned at the beginning of this book: fine art and NRM-inspired art are understood as potentially equal because they are equally sincere. Looking at the results as art, however, raises different questions.

An example of a male artist who creates altarlike sculptures is Michael Tracy. His work is different from the artists Turner studies because it is inspired by his experiences in Latin America, where the United States supported torture and murder in the name of combatting communism. His enormous *Triptych: 11th, 12th, and 13th Stations of the Cross to Latin America, La Pasión* (1981–88) is an ambitious example (it is visible in the back of plate 27). "My bitter heart-breaking rage and frustrating thirst for justice exist unquenched," he writes. The ruined, bloody altars he creates make bitter fun of the "baptism by blood," the "sacramental death" in the name of democracy, and the horror of discovering that "the body

and blood of Christ ineffably and ironically is our body and our blood."
I take it as a sign of the danger of treating all idiosyncratic altars as poten-
tially equivalent objects that Tracy's work, judged just by its appearance,
could be taken as antireligious or even as an experiment in private spiri-
tuality skin to Saar's.[26]

Often the line between altar-as-art and art-as-altar is blurred. For the
artist Rose Wognum Frances, "altar-making is a choice to keep your spir-
itual life alive on a daily basis, to surround yourself with it, to immerse
yourself in it and in the beauty of it, the objects of it, the community of
it."[27] When she was a teenager, she made altars of moths' wings,
pinecones, and rocks. In 1982 she constructed an altar called *Mr. Bear's
Mantle* (figure 21). It houses a relic, a cloak for a stuffed bear that the
artist made out of silk, cobwebs, leaf ghosts, and dragonfly wings. For
Frances, the stuffed bear—whose image is on a gold leaf lunette at the
top—represents her relation to her mother, who had given her the bear
when she went to boarding school. Frances says she understood that the
bear was a surrogate for a kind of intimacy her mother could not bring
herself to give. As art, the altar is very much in line with work from the
1980s that used hair, lint, dust balls, and other ephemeral materials. I
have had students in my own classes who made teddy bear artworks with
very personal meanings. One woman knitted a deformed teddy bear out
of uncured animal skins. It looked rancid, and some students in the class
thought it was disgusting, but she loved it. Frances's altar is kin to that
pathetic, rotting teddy bear, but it is modeled on a medieval Christian
altar with all the trappings: it has a relic, a reliquary with folding doors,
an icon, gold leaf, a lunette frame, a base, and several inscriptions. It is
an altar made as carefully as an artwork, and it is also an artwork in the
form of an altar.

Work done in the name of new faiths is astonishingly diverse. It is
arguably more challenging to study art inspired by NRMs than it is to
study Catholic or Protestant work, because the range of references goes
all the way from hypothetical Old European goddesses to the latest fem-
inist theory. A history of NRM art has yet to be written, but I wonder if
one ever will be. In his book *An Art of Our Own: The Spiritual in Twen-
tieth-Century Art*, Roger Lipsey says the art he is interested in "needn't
even be called 'the spiritual,'" because "words of some kind will be found
to describe an intelligence, a vitality, a sense of deliverance from petti-
ness and arrival at dignity that always seem a gift."[28] Definitions that gen-
eralize are apt to escape any survey. An ambitious exhibition in Bologna
in 2000, titled "Shadow of Reason: Exploring the Spiritual in European
Identity in the 20th Century" also proposed a less than coherent defini-

Fig.21. Rose Wognum Frances, *Mr. Bear's Mantle*. 1982. Courtesy of the artist.

tion of its own scope. The show's principal curator, Danilo Eccher, asks if there could be "a shadowy territory, obscured from Reason, a sort of other side of the moon where thought is clouded due to an uncertain and indefinable presence."[29] Eccher's exhibition catalogue is entertaining because he generously includes essays by some well-known authors who turn out to be skeptical of the exhibition's purpose. Umberto Eco's contribution begins: "Allow me to gingerly admit some perplexity [*qualche cauta perplessità*] concerning the title of the exhibition and the group of artists who are supposed to warrant it."[30] In another essay the philosopher Gianni Vattimo identifies the early 20th-century avant-garde with the "Expressionist character," and says that its spirit is "the principle of chaos, of a breakdown [*rotture*] of established norms"—hardly what the exhibition itself seems to imply.[31] The show itself ranged from Edvard Munch to Anselm Kiefer, Umberto Boccioni, Francis Bacon, and Giorgio Morandi: an eclectic selection with little common ground. Among the artists are some that could be called spiritual, including Wolfgang Laib's installations of pollen painstakingly gathered by hand, one flower at a time. Laib's sense of nature draws on Hinduism, pantheism, and late Romantic nature worship, all put to the service of a personal spirituality. The same catalogue includes Christian Boltanski, whose principal interest is the visual scars left in history caused by the Holocaust. If that is the same kind of "shadowy territory, occluded from Reason" as Laib's pollen samples, then the category is capacious enough to admit most of 20th-century visual art.

Even if it were possible to define the art of new religious movements, writing its history would demand an historian as erudite and wide-ranging as Erwin Panofsky, Mario Praz, or Arnaldo Momigliano, scholars of the arcane symbols of the ancient world and the Renaissance—and at the same time it would require a writer who can remain interested in the artistic content of the work (as Turner and other anthropologists need not), even when the work has low artistic quality or functions more as illustration than art.

Brian's Story Explained:
Art that Is Critical of Religion

BRIAN, THE STUDENT WHO MADE THE CIBACHROME ELVIS crucifix-ions, is an example of an artist who feels alienated from religion and wants to use his or her art to stir up some controversy. It's an open secret in the art world that the best-known antireligious artists aren't really against religion. Andres Serrano, whose *Piss Christ* caused such a stir, is a committed but skeptical and conflicted Catholic. His house is filled with Baroque religious sculptures. The same is true of the Argentine artist León Ferrari (see figure 15), and Andy Warhol's versions of Leonardo's *Last Supper* are other examples (see figure 22). Warhol was a devoted Catholic, and the fact that he staged the opening of his exhibition of *Last Suppers* across the street from the original in Milan doesn't necessarily mean that all he had in mind was publicity; it has even been argued that the paintings are a kind of confession of faith.[1]

Perhaps the most interesting religious art is critical but open-minded, or deeply undecided. That is what I mean by "art that is critical of religion": not only art that criticizes religion, but art that ponders religion from a few steps outside it. A few years ago at our graduation exhibition, one of the school's students exhibited underwear stitched with beads in the form of religious scenes, like the ones on large votive candles. At first it seemed like a deliberate insult, but later I found out the student was trying to work through issues about the church and sexuality. Using underwear wasn't entirely successful, because it could be easily misunderstood as a cheap shot at sanctity, but it wasn't simply antireligious. It is possible to imagine contemporary art that is critical of religion as a spectrum: on one side is the work that rails against the church, and on the other side work that simply asks that viewers reconsider ideas about religion. The first option is the ultraviolet of antireligion, and it tends to be heated and combative. The second is the infrared of critique, and it can be low energy and less definite in its ideology. Brian's work seems like the

Fig.22. Andy Warhol, *Last Supper*. 1986. ©The Andy Warhol Foundation, Inc. Photo: Alinari/Art Resource, NY.

ultraviolet end of things, but actually is closer to the infrared. Brian was not emotionally or philosophically attached to his work. His crucified Elvis seemed antireligious when I first saw it, but it wasn't, really, because Brian didn't care that much about Catholicism. He could have been an atheist, or an agnostic. He did not say, and it didn't matter for his art.

Brian's Elvis and his Madonna-as-the-Madonna photograph were semisacred even in their semisecularity. After all, Elvis *is* a kind of saint to some people. The critic Harold Bloom has studied the American pro-life movement, and he thinks there is a parallel between placards of unborn fetuses that are paraded in front of abortion clinics and traditional images of the baby Jesus.[2] Both are rallying points, both inspire intense devotion, both are images of precious lives that needed to be protected. (He also

makes a parallel between the American flag and the cross.) Bloom is eccentric to think that the fetus and the flag are new religious icons, but he is not wrong to point out that religious images are always being reinvented, and secular images can be covertly religious.

The most virulent antireligious thinking hasn't been in visual art, but in theology itself. No artist I know is as dogmatic as to say, as the historian Friedrich Max Müller did in the late 19th century, that religion is merely a "disease of language."[3] One reason Manet's *Dead Christ and the Angels* is not an illustration of Renan's naturalized religion is because it is still clearly about a sacred subject. I do not know any artists who would bother to debate the proposition that "the whole Divine law ... has come down to us uncorrupted," which is what Spinoza first doubted in the 17th century; and I have yet to see an artwork illustrating Nietzsche's famous and often misunderstood aphorism "God is dead."[4] The enormous issues of the past have floated away, and the current generation of artists is not against anything as large as religion or truth.

Truly antireligious artwork, the ultraviolet kind, is a minority. It lightens by invisible grades into work that is conflicted about religion, like Serrano's, and then it fades into the dimmer shades of work that has nearly lost its anger and it seems the artist is thinking of other things, as in Brian's work. In their apparently careless disregard of serious antireligious polemic, contemporary artists are following another long-established tradition: the history of learning to ignore religion, instead of railing against it. In the Western tradition, the Greek philosopher Epicurus was among the first to do this. He thought the gods had nothing to do with people, that they lived in "flat" places "between" worlds (he called them *intermundia*), and that in any case the gods were too weak, too rarefied to care about what happened on Earth.[5] I don't think Freud wrote about Epicurus's theology; if he had, he might have said that Epicurus had worked through the psychological dependence on divinity and even through the rejection of that dependence. Epicurus did not resent the fact that the gods had gone away. Like forgotten parents, they were neither loved nor hated. (In that, Epicurus was different from the plangent melancholy of romantic poets like Friedrich Hölderlin and Gérard de Nerval, who swooned when they thought of how far away the gods had gone.) Though Freud decried the dependence on the "illusion" of God, I wonder if he imagined it would be possible for God the Father to be so thoroughly divested of power, so absent from a person's affections or thoughts, that he might vanish into the Empyrean as the Greek gods did for Epicurus.[6] That, as far as we can tell from the surviving texts, is what Epicurus achieved. It is a parallel road to the one that Brian was on when he put

his last Elvis on the cross. He was on the way from hating to not caring. There is a wonderful long word for Epicurus's achievement (in fact, the longest word in the dictionary that is not a scientific neologism): floccinaucinihilipilification, the act of saying something is without value. It can be difficult to achieve in the case of religion; most work critical of religion, from Warhol's to Brian's, still has an edge.

Brian was in a class of mine in which we looked at the transformations of common symbols. It's a surprising fact that at one time in the ancient Near East, crosses were made from swastikas. Take a swastika and dismember it as in Diagram 1. Rearrange it, shifting each piece clockwise, and you have a Greek cross as in Diagram 2. This little trick (swastika = cross) is like Brian's little trick (Madonna = the Madonna).[7] They are part of the same game of mutable religious symbols. Visual culture is permeated with examples. In a medieval manuscript, a saint is decorated with three swastikas, each one formed by four axes with their blades touching (See figure 23).[8] The manuscript is the *Hours of Catherine of Cleves,* and the swastikas are, of course, entirely accidental. Before nazism, Western artists shifted indifferently from swastikas to their mirror images, sometimes called *sauvastikas.*[9]

Diagram 1. A Swastika, disassembled.

Diagram 2. A Greek cross.

Fig.23. St. Matthias Apostle in *The Hours of Catherine of Cleves*.
1435. Pierpont Morgan Library MS 917, p. 235.

In the class I also introduced examples from non-Western cultures. In India, the Jain *devīpujā* (देवी पूजा, "shining worship") ritual involves swastikas and crosses, along with labyrinths (See figure 24). Each worshiper pushes grains of uncooked rice into a design that represents the courses that his or her life may take.[10] The designs are slightly different for each person, but they are built around the swastika, an emblem of the four possible lives: incarnation as heavenly beings, human beings, animals, and hellish beings. At the top is a crescent moon, cradling a single dot: the *siddha*, resting place of enlightened souls. Jain worshipers also call the swastika *sauvastika* or *sauvastikayantra*, and the whole diagram *nandyāvarta* or *nandyāvartayantra* ("diagram of the *nandyāvarta*"). The swastika and this *yantra* (diagram) are two of eight auspicious symbols in Jain religion.

If there is one thing that everyone knows about crosses and swastikas, it is that they are ubiquitous, crowded with meanings, and therefore in danger of collapsing into meaninglessness. Even when they were not decoration, some ancient crosses, like some ancient swastikas, may have symbolized nothing. Carl Jung thought that the reversed swastika, called a sauvastika, symbolized ideas tunneling into the unconscious. Müller thought they symbolized the autumnal sun. In the past, swastikas have meant goodness, the Third Reich, the spring sun, Jaina redemption, the four directions, and nothing—either nothing in particular or nothing at all. That is the condition of religious symbols, as Hegel said; they combine the specificity of "natural" meanings (the cross is also a crossroad, as in the *devāpujā* rice maps) with many other meanings that are unrelated, from the Third Reich to the accidental configuration of hatchets in the *Hours of Catherine of Cleves*.[11]

Brian found that part of the class congenial, perhaps because it gave him license to play with symbols. Any cross, any swastika or sauvastika, might also be just decoration, or so I thought Brian hoped. Brian's game of transmuting symbols was also religion's game, except that Brian was playing the easy part, stressing the fact that religious symbolism is arbitrary. He wanted to say something jokey against Christianity, and also to make a work that would mean different things to different people. His colossal Cibachromes were not successful art, but they were on their way: they were better, at least, than the plastic "BEAM ME UP SCOTTY" crucifix. Art that trumpets its discontent with religion can seem too strident, too superficial. The many shades of gray, the conflicted second thoughts, are where art begins to happen.

Brian's art, when I saw it, was working its way out toward the infrared

Fig.24. A Jaina devapuja ritual. From Jyotindra Jain and Eberhard Fischer, *Jaina Iconography*, 2 vols. (Leiden: E. J. Brill, 1978), vol. 1, pl. VI (a). Used with permission of Jyotindra Jain.

of carelessness. There is another mode of contemporary art production that is antireligious, but is fumbling its way toward something that might eventually be a kind of faith. An example is the images that have been seen in the eyes of the miraculous image of the Virgin of Guadalupe, a miraculous image imprinted on a *tilma* (a Central American garment) on December 9, 1531 (see figure 25).[12] The story begins with Alfonso Marcue, who was the official photographer for the Basilica of Guadalupe in Mexico City. In 1929 he was photographing the tilma and found the reflection of a bearded man in the image of the Virgin's eye. Then, in 1979, José Aste Tonsmann of the Mexican Center of Guadalupan Studies, magnified the Virgin's eyes 2,500 times (the practical limit of light microscopy) and discovered the reflections of at least 13 people that, he supposes, the Virgin must have been looking at on December 9, 1531, when the miracle occurred. Among them are Bishop Zumárraga, who is known to have been at the scene; the interpreter Juan González; the Indian Juan Diego, who unfolds his own tilma in front of the bishop; a female Negro slave who is known to have been in the bishop's service; and a man with Spanish features.[13]

Fig. 25. *Virgin of Guadalupe*, detail. 1531. Guadalupe, Mexico.

All that is background. The slow drift back toward faith can be seen in the work of the American artist Jeffrey Vallance, who took Tonsmann's findings a step further. Vallance looked into the Virgin's eyes on the tilma and found "over seventy-five simian faces, all looking embarrassingly like popular versions of Bigfoot or Yeti (Abominable Snowman)." Vallance's website diagrams a dozen or so (see figure 26). He says that he was not sure of the significance of his finds until he discovered that "in Mexico, the Spanish name for the Devil is the traditional term *chango*, or 'monkey,' " so that the miraculous Virgin's vision records apparitions of the devil, as reported in an early source. Vallance adds that other apparitions have also been seen (he does not quite say by whom), including "a shroudlike portrait of Christ, several profiles of Elvis (either looking up in adoration, or with eyes closed as if in prayer), . . . an image that looks somewhat like folk singer Bob Dylan (during his 'born Again' experience),

Fig.26. Jeffrey Vallance, Simian and human figures in the left eye of the Virgin of Guadalupe. From *http://www.sixty-five.com/jeffreyvallance/*.

... a diabolical visualization of cult leader Charles Manson, an image of famed Mexican wrestler and political activist Superbarrio, a profile of President Abraham Lincoln, and the carcass-imprint of Blinky, the Friendly Hen."[14] This is all presented seriously, but at the same time none of it is really meant to be believed.

The usual art world reading of Vallance would be that it's a snide kind of camp, a jokey fake-serious send-up of the pole-faced findings of the official church. There is truth in that, but I also think of work like Vallance's as the tentative beginnings of a new kind of belief. He is making fun of the church and its acceptance of the reflections in the Virgin's eyes, but at the same time he has spent a lot of time finding his own figures and providing them with elaborate technical and textual justifications. In the language of the art world, Vallance's work is simply fun—it's campy, quirky, and entertaining to explain. Yet it is also tentative and coy, because there is meaning behind the playful antireligious veneer. Why trouble yourself with the complicated history of the Virgin of Guadalupe if something doesn't draw you to it? And if you find Vallance's work funny, then you might ask yourself why. There is a serious content somewhere just beyond work like Vallance's or Brian's. It cannot be avowed: the only thing that can be said aloud is that old religious meanings seem ridiculous. But the work is about religion: it experiments with religious meanings, as if it were searching for a way to stay near religion—in Vallance's case—or to drift away from it—in Brian's.

The artworks I mention in this book are just scattered emblems of a vast territory, mostly unexplored in scholarship. Consider, as evidence of the breadth of the phenomenon, the exhibition catalogue *Faith: The Impact of Judaeo-Christian Religion on Art at the Millennium*—or, as the cover copy puts it, "This is not your ordinary art catalogue, this is *Faith*." Most of the artists in the exhibition were interested in using contemporary art to say something about religion. There is one of Hermann Nitsch's bloody installations (a record of one of his invented rituals); a large cast concrete model of a church mounted upside down by Nicholas Kripal; Kinke Kooi's *O, God,* an Ed Ruscha-type painting that depicts those words as if they were a swirl of cotton candy; a painting of the crucifixion, R. Crumb-style, by Manuel Ocampo, overwritten with slogans including "*Invalid forms of inward looking*"; a very serious tinted photograph of Jesus guiding the hand of doubting Thomas, done in professional-looking style by Bettina Rheims and Serge Branly; a book by Diane Samuels embroidered with a prayer beginning "Dear God, I do not know how to pray"; Linda Ekstrom's table of blood samples on silk, called

Fig.27. Museum of Contemporary Religious Art, St. Louis. Installation view, showing work by Michael Tracy (back wall), works by Michael David, Daniel Smajo-Ramirez, Bernard Maisner, and Ann McCoy. Courtesy Terrence Dempsey, Director, MOCRA, St. Louis.

Menstrual/Liturgical Cycles; and many works in minimalist, abstract, and expressionist idioms.[15] Many related works are held in the collection of the Museum of Contemporary Religious Art in St. Louis, Missouri, including paintings by Michael David, Daniel Smajo-Ramirez, Michael Tracy, Bernard Maisner and sculptures by Ann McCoy (see figure 27).[16] There is, it seems, no end to the examples.[17] A flood of art addresses itself to religion without quite being religious itself.

Ria's Story Explained:
How Artists Try to Burn Away Religion

EVEN THE BEST WORK THAT IS CRITICAL OF RELIGION is somehow dissatisfying as art. It feels like painting or photography is being *used* for an inappropriate purpose. If the real purpose is to criticize religion—whether the work is moving back toward faith or further away—then it seems that art is just a convenient vehicle. An antireligious billboard would do as well. Art like Brian's is out of place when it is shown alongside art that uses the same media but has no religious message. Brian may have sensed that when he stopped making wall-sized Cibachromes with glowing Elvises and turned to wall-sized Cibachromes glowing with sexual innuendo.

Ria, the student who made the ceramic house of the 14 Stations of the Cross, was a different case from Brian. She wasn't trying to poke fun at anything, or show off her cynicism. She was looking for something in her parents' religion that she could accept.

The process, for Ria, was like subtracting small amounts from a huge sum. Beginning with the total of everything she experienced in Catholicism, she took away the parts she imagined her parents loved. She had originally sculpted a church, and then she omitted the altar, the chalice and candles, the flowers, the choir, and the organ. She did away with the beautiful architecture, the stained glass windows, the paintings, the gilded moldings, the ribbed roof, and the flowery stucco. There were no pews, no confessionals, and no font. She did not want to represent any of the liturgy or the Mass, or the priest or the worshipers. Eventually the sculpture became a wobbly clay church that looked more like the Addams's family mansion.

Still it was too literal. She had sculpted little figurines representing the 14 Stations. She pulled them out, leaving scars in the dollhouse floor. She dumped glaze over her deconsecrated church, ruining its straight lines and arches. When she fired it, the whole edifice cracked.

Ria was not sure what she had made, but she hoped it meant something. At least nothing in it offended her, and in that respect it was true to what she could believe in. But she was uncertain about it, almost puzzled. She wasn't sure what it was—which is another way of saying she wasn't sure how to picture what she believed in.

It would have been easy to just push the clay around a bit more, and the sculpture would have turned into a heavy block of fired clay and syrupy glaze. She didn't quite go that far, because she wanted to retain an echo of the 14 Stations. She stopped in a strange place, most of the way along to abstraction, and very far from anything a viewer would guess was a church. Was *that* what she was looking for at the heart of Catholicism, hidden away under the scriptures and brocades?

Ria did not know it, but the Romantics had first adumbrated her process of subtracting away the trappings of the church. I mentioned the German Romantic painters Caspar David Friedrich and Otto Philip Runge, whose work was intended in part to strip away the ceremonies of the church to get at the living religion inside. The idea that the signs of religious devotion are like a hard dead shell concealing a living form inside is an idea theorized by German philosophers such as Johann Gottlieb Fichte and Friedrich Wilhelm von Schelling, and before them, Johann Wolfgang von Goethe.[1] The idea persisted through the late 19th century and flourished in the revival of the occult and mysticism that mark much of *fin-de-siècle* European painting.

Landscape painting was steeped in meaning for artists like the late 19th-century American George Inness. He strove, as he said, to breathe "the sentiment of humanity" through "rivers, streams, the rippling brook, the hill-side, the sky, clouds—all things we see." For him they expressed "the love of God and the desire of truth."[2] It isn't necessarily easy to put transcendentalist beliefs like Inness's into words, any more than it is straightforward to say what Wordsworth thought of mountains or pastures. They felt religiously about nature, without always speaking about religion. The same kind of observation can be said about many 19th-century nature painters. The wonderful Emily Carr, a Canadian painter, thought a great deal about the Canadian pine woods and their relation to her own sense of God and her understanding of First Nation art.[3] These few, nearly random examples are just the beginnings of an enormous scattered practice of spiritual landscape painting. It has been said that landscape, as a genre, has never released itself from Romantic sentiments. (That is what makes it both strong and old-fashioned.)

The first generation of abstract painters, including Wassily Kandinsky, was steeped in theosophy and mystical nature worship. The artists studied

the Russian mystic Helena Blavatsky and read theosophy and occult texts.[4] Kandinsky, Mondrian, and Malevich all read Eduard Schuré's *Les grands initiés,* a grand tour of the great figures of the world's religions.[5] Painters read, or read about, the *Corpus Hermeticum,* the kabbalah, Emanuel Swedenborg, Petr Dem'ianovich Uspenskii, and the mystical writings of Gérard d'Encausse, known as Papus, whose books number three hundred volumes.[6] For some modern artists, abstraction was a skeleton key to a truth higher than naturalism and beyond mere paint and canvas. As Rudolf Steiner said, "what appears in painting is a depiction of something supersensible," a "revelation of the spiritual world." Steiner dismissed mundane interpretations of art, as in this lecture given in 1920:

> Generally speaking, what are people's attitudes toward the arts that reveal a spiritual world? Very much like that of a dog toward human speech, actually. The dog hears human speech and presumably supposes it to be a bark. Unless it happens to be a particularly intelligent performing animal, such as the one that excited a lot of interest some time ago among people who concern themselves with such useless tricks, it doesn't understand the meaning that lies in the sounds. This is the attitude of human beings toward the arts, which really speak about the supersensible world we once experienced: We do not behold in them what they really reveal.[7]

Painting, from a theosophical perspective, is a remnant of a lost communication with the spiritual world beyond ordinary vision.

The early abstract painters' spiritual interests were sidelined by academic scholarship until the 1970s, when exhibitions such as *Perceptions of the Spirit in Twentieth-Century American Art* and later *The Spiritual in Art: Abstract Painting 1890–1985;* both exhibitions also revived contemporary artists' interest in the spiritual element in their own work.[8] In my experience *The Spiritual in Art* remains a watershed work in studio instruction. (The earlier exhibition *Perceptions of the Spirit* is not about abstraction, but rather early to midcentury painting, including West Coast artists such as Jess and Jay DeFeo.) People are mistaken to say that abstraction is meaningless. Maurice Tuchman, in an essay titled "Hidden Meanings in Abstract Art" in *The Spiritual in Art,* states to the contrary that "an astonishingly high proportion of visual artists working in the past hundred years" were interested in "spiritual ideas."[9] The question is just how "astonishingly high" the proportion was, and what else early abstraction (or abstraction in general) meant.

Some abstract painters, such as Charmion von Wiegand, continued

their spiritual interests well past World War II, creating a continuous tradition of mystically informed abstraction informed by theosophy and spiritualist movements. In 1946 Wiegand read Madame Blavatsky's *Secret Doctrine,* a bible of *fin-de-siècle* mysticism, and she continued to paint personal visions of divine truths into her old age (see Figure 28).[10] Needless to say there are many more abstract painters who can't be described as spiritualists, among them Nicolas de Staël, Jackson Pollock, Willem De Kooning, Phillip Guston, Franz Kline, Pierre Soulages, Frank Stella, Robert Morris, Jules Olitski, Larry Poons, Sean Scully, Simon Hantaï, Martin Barré, Antoni Tapies, Cy Twombly, Jean Fautrier, Daniel Buren, Sam Francis, Joan Mitchell, Helen Frankenthaler, or Ellsworth Kelly. To understand work like theirs, it is necessary to bring in the many secular discourses on abstraction and to think differently about the history of painting, the importance of medium, and the limitations of self-reflexivity. Even within the first generations of international abstraction, mysticism and spirituality provided no unity. It is not always enough just to look at the paintings: on the surface, some of von Wiegand's paintings look like Mondrian's, but their purposes were worlds apart.

In art history and criticism, the *Spiritual in Art* exhibition has been sidelined in favor of the other meanings of abstraction. At least one exhibition was set up as an answer to *The Spiritual in Art:* it was called *The Non-Spiritual in Art: Abstract Painting 1985–????,* and it included mainly minimalist abstraction. The curator, Kevin Maginnis, wrote that if spiritual abstraction works its magic by "silence and alchemy," his alternate abstraction would make use of "words and science." Maginnis is stubbornly antitranscendental. "Ornament makes no claim at transcendence," he writes, deliberately demoting the high aspirations of the *Spiritual in Art* by using the forbidden word "ornament."[11] *The Non-Spiritual in Art* is not typical of the scholarship that wants to avoid spirituality, but it stands for a minority opinion in art practice and a majority opinion in history and criticism. Steiner's idea, that painting points to a supersensible reality, is the diametric opposite of the academic understanding of abstraction. For art history, abstraction is about the society that produced it and the material and history of painting itself: anything but the "supersensible world" that Steiner and some of the early artists thought so much about. Historians like T.J. Clark do not even use the word "spirituality" ("religion" would at least sound more reliable): academic conversations employ the words "transcendental" and "enchantment" instead. That, it seems to me, is the most sensible way to proceed. Those words do not beg the question of *what* is denoted; transcendence has an impeccably philosophic pedigree, and enchantment hails from psychology rather than

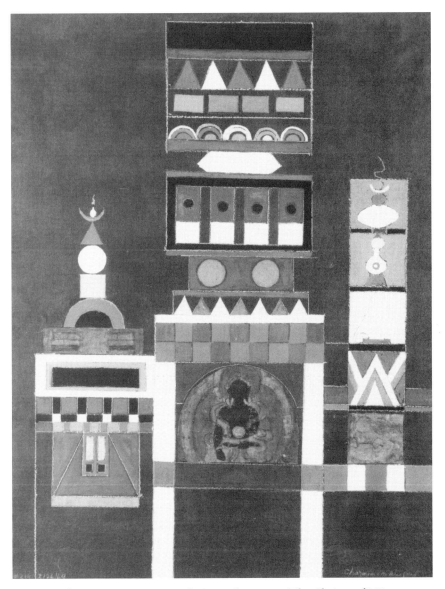

Fig. 28. Charmion von Wiegand, Gouache #219: *The Shrine of Mirror-Like Wisdom*. 1964. Photograph courtesy of Michael Rosenfeld Gallery, LLC, New York.

theology. The most interesting conversations about modernism's suspicion of transcendence and the potential for the reemergence or "re-enchantment" of the world take place in texts that are nearly sealed off from religious discourse. They do not even appear as religious texts, and "religion" won't appear in their indices, but that is the only way forward when what matters is the art's meaning in, and for, art history.

(To date the best book on modernism and the renunciation of transcendence is T.J. Clark's *Farewell to an Idea*, which provides one of the two epigraphs for this book. To date the best response to Clark, arguing for a limited function for "reenchantment," is Michael Fried's book *Menzel's Realism*. Fried's argument turns on just one painting by the German realist Adolph Menzel, a painting of "a stretch of bare ground crossed by wooden fences and littered with signs of construction." Fried proposes that a "vividly evoked" disenchantment in that scene "turns out to be a compelling source of fascination, even reenchantment." Notice the same word, "re-enchantment," as appears in Suzi Gablik's writing, even though the two are worlds apart: a perfect example of the difficulty of speaking across the widely scattered discourses on religion in art.)[12]

If I cast my lot with the "nonspiritualists" it is not because I think Kandinsky wasn't spiritually inclined. It is because what gives the art lasting importance is what it does *other* than affecting the kinds of spiritual communication Kandinsky hoped for. He had elaborate ideas about his work; he thought, for example, that every acute angle is associated with a shrill tone, but has anyone read one of Kandinsky's paintings that way? There is evidence Kandinsky himself didn't follow his own rules, preferring more general interpretations to form-by-form exegeses.[13] By the end of the 20th century, artists had still not decided what spiritual truths lay beyond painting or exactly how much of religion needed to be burned away to get at those truths.

A catalogue of modernist attempts to purify religion by unfocusing its dramas or blending its symbols into abstractions would be as long as the familiar lists of styles and isms. James Rosen's *Homage to Grünewald, The Isenheim Altarpiece* (1975) is a version of Grünewald's central panel, with the St. John and Magdalene blurred. Does the blurring make the Renaissance original more acceptable as a modern religious image? Jim Morphesis's *Colmar Variations* (1980) is in the shape of Grünewald's altarpiece, but it contains nothing but smeared abstract forms. Is *that* enough blurring? Writing about Rosen's painting, John Dillenberger says "we are psychologically drawn into it in a way the original does not and cannot do."[14] But if that is the case, why stop there? Why not erase

Grünewald's painting altogether, like Morphesis does, or even erase *painting* altogether, leaving only the idea?

In the book of Exodus, Moses asks to see God, and God tells him to hide in a cleft in the rock. God puts his hand over the cleft, walks by, and lifts his hand, and Moses sees God's back. The person who does not look at God survives, and the one who looks must die. The episode in Exodus would not make a convincing scene in a movie (How does God put his hand over the rock while he is walking? What does the divine back look like?). Even the movie *The Ten Commandments* avoided it. But it is echoed in the climactic scene of the movie *Raiders of the Lost Ark*, where a group of Nazi soldiers have captured the Ark of the Covenant. They intend to open it, and they have brought the hero and heroine along and tied them to a stake. At first they watch, but then as the angels of death emerge from the Ark, Indiana tells his friend to close her eyes. The Nazis have no such compunctions and of course they all die. The same idea is secularized in the movie *Twister*. In one scene, Jo and Bill spot a tornado, and the sound-track plays a wordless chorus reminiscent of *Carmina Burana* to signal their awe. (Wordless choral music is a traditional signal of the sacred in a wide range of modernist music and film, from Schönberg's *Moses und Aron* to *The Omen*.) Jo and Bill hide under a small bridge, and as the tornado approaches, Jo starts crawling out. "I want to see it," she says, but Bill pulls her back and tells her to close her eyes. The tornado passes overhead, and they survive. The tornadoes in *Twister* work as religious objects exactly because their religious significance is never made explicit. The same camouflaging—light, but sufficient—operates in contemporary art. The strategy would be to burn away as much of the emblems of religion as necessary to get at something that is not immediately recognizable as religious, but is—for that same reason—more genuinely religious than an overt symbol could ever be.

The historian of religion Mircea Eliade calls this "the quest for the unrecognizable sacred." He thinks that the "death of God," announced in 1880 by Nietzsche, "signifies above all the impossibility of expressing a religious experience in traditional religious language: in medieval language for example, or in that of the Counter-Reformation."[15] Eliade's idea captures the spirit of Ria's, Rosen's, Morphesis's, and even Kandinsky's enterprise, but I have not used the phrase "quest for the unrecognizable sacred" because even that would sound overblown to some artists I know. (I don't know any artists on *quests*—that is what you do when you're after the Holy Grail, or the Ark of the Covenant, or Noah's Ark.)

The idea that the holy must be defaced or camouflaged in order to reveal itself can be traced to before Eliade, all the way to the ancient philosopher Plotinus, who thought that religion should be the search for what he called One (ἕν ὄν), which exists wholly in itself (ἐν ἄλλῳ), rather than a collection of rites and rituals.[16] For Plotinus every work of art has something divine in it, but the divine cannot be contained in an image. His philosophy is nonvisual and even antioptical; he did not agree with the Stoics and others who identified beauty with symmetry and proportion because he felt that each visible form was only the reflected light of the One, which he called "the formless." "This formless form," he wrote, "is beautiful as form, beautiful in proportion as we strip away all shape, even that given in thought to mark the difference between two things ... which are beautiful in their difference." Shape, to Plotinus, "is an impress from the unshaped," because "it is the unshaped that produces shape."[17] Beauty, therefore, "must be formless."[18] The eye sees forms because it is "held by the illuminated object," but there is also a "medium by which the eye sees." Inner light, inner form, is what matters, not outward appearance.[19] (Eastern parallels are irresistible. There are incrementally close parallels to be had in the *Kena Upanishad,* which distinguishes the eye from that which permits the eye to see. Its author asserts the difference between "that which one sees ... with sight," and "that with which one sees sights." Unlike Plotinus, however, the *Upanishad* would not have been known in Europe before the eighteenth century.)[20]

Plotinus did not write about art, but he had tremendous influence on Byzantine art, on Renaissance neo-Platonism (with which Michelangelo was loosely allied), and on modernism.[21] An example among many is the exhibition catalogue called *Formless: A User's Guide,* which is concerned with the heritage of surrealism; it does not mention Plotinus, but it would be unthinkable without him.[22] What has mattered to later generations is Plotinus's insistence that the mind approach the invisible, that visible appearance is not enough, that there is a continuous call to invisibility, unrepresentability, and the formless.

Kandinsky might have agreed with some of Plotinus's ideas, especially the notion of leaving real color and shape behind in favor of the unrepresentable spirit they express. But Ria would not want to describe what she does in Eliade's terms, or even in Plotinus's. Kandinsky comes across as too literal, too obviously spiritual. Even the word *sacred,* as in Eliade's "quest for the unrecognizable sacred," is too coarse. The title I chose for this section, "burning away religion," is meant to conjure the feeling that religion is closed up tight inside its churchly armature. It has to be broken into, scraped off, burnt away. Saying more than that would be saying too much.

Let me count down some strategies for finding the heart of a religious practice as an artist like Ria might imagine it, starting with moves that leave the religious symbolism largely intact, and ending with those that render religion into something barely recognizable.

Consider first an elementary part of religious worship, the altar. What is an altar, in this way of thinking? Not much more than a platform with an arrangement of objects on top. An altar painting or sculpture could then be considered as an abstract image. The photographer Ajit Mookerjee has taken some unique pictures of altars in rural southern India that conform to this notion of a stripped-down altar or altar painting. In one, a village deity is nothing more than an unexpected bulge in the wall, with two eyes painted on it, as if a face were emerging from the building itself (See figure 29).[23] There is probably no transcultural continuum of ideas linking Ria with southern Indian altars. What I mean is that the late 20th-century aesthetic of simplified and partly erased religious forms found a natural expression in Mookerjee's choices. (Her book couldn't have appeared before the 1960s, in other words, even though simple roadside altars had been made in India for millennia.) Mookerjee's photographs harmonize with the aim of destructions like Ria's: they show how altars and church paintings can be as simple as tables, lumps of clay, and pictures done in rice paste.

A next step would be the dismantling of the church or temple itself. Again Indian practices provide striking parallels. There are holy men in southern India who practice a variation on the ancient worship of *prāna* (फराण, breath) and *agni* (अग्नि, sacrificial fire). They sit on the ground inside a sacred space, which can be limited by nothing more than a few feet of string.[24] The fire itself is given its own enclosure, as if it were an altar within the sacred space of a church. There is almost nothing left of the conventional structures of the sacred building, altar, *sanctum,* and *sanctum sanctorum:* in their place are the simplest of distinctions between the ordinary world and the sacred one—a string boundary around fire, as fragile and as evocative as the cordon around an artwork.

Another possibility is to search for the sacred outside of churches, in ordinary life. Since the 19th century, Dutch genre painting has been interpreted as a way of representing what is spiritual or sacred in domestic life. Hegel said as much, although it has proven difficult for even the most attentive art historians to tease out the subtle religious overtones of lemons, goblets, rugs, stray dogs, windows glowing in afternoon light, or women playing spinets.[25] Carl Gustav Carus, a friend of the Caspar David Friedrich's, said it most concisely: in these images nature is "mysterious in broad daylight."[26]

Fig. 29. GramAl\-devatA\, a village deity. West Bengal, India. c. 1985.
Photo: Priya Mookerjee. From *Ajit Mookerjee, Ritual Art of India*
(London: Thames and Hudson, 1985), pl. 42.

Consider for instance Frans Francken II's painting, in which several men gather at a table in a room full of curiosities (see figure 30).[27] Against the back wall there is a piece of furniture that appears to be an altar, but might also, in a characteristic double meaning, be a side table. On it are two religious images, in addition to a cone shell and a whelk, which do not belong on an altar, and the table or altar has secular paintings all around it.

And what about the table to the right, with the vase? It looks a little funereal, with the portrait propped against it. Perhaps it is a bier, the kind of memorial that can still be found in funeral parlors and in people's homes during services. But it is not a bier, exactly. Maybe it is what we would call a coffee table or side table, set up to display the portrait.

The table where the naturalists sit is arranged as it would be in a traditional Baroque painting of worldly objects, the type called a *vanitas* painting. On it is an armillary sphere, used to map the stars, a book, and a selection of natural wonders. If Francken had just painted this table, without the "altar" or the "bier," the painting would have been understood as a vanitas, a message about the transience of worldly things. But it is more than that, because the various objects also comprise a small museum—a cabinet of curiosities—in their own right.

Fig. 30. Frans Francken II, *Gallery Interior with Justus Lipsius and Abraham Ortelins*. 1618. Philadelphia, private collection. [P. A. B. Widener collection]

Altar, side table, funerary arrangement, coffee table, museum: none of these readings is subtle enough, because the tables are not really altars, biers, or curiosity cabinets. The painting depicts a collection of art and curiosities, together with its owners, but that is not quite the whole story. It is a little museum, but it is a museum with an altarlike table, and a bierlike table—there just is not any clear way of putting it.

Considering more ordinary interior spaces can further blur the religious meanings of altarlike furniture. Even common contemporary furniture can refer to religion in a gentle and indirect fashion. I might suppose the desk in my office is like an altar, but only if I think about it. My computer is front and center, and there is some symmetry to the objects around it. But the arrangement is only altarlike if I deliberately imagine it that way, and otherwise the thought never crosses my mind. The nests, files, and arrays I make of the objects that I own rarely signify anything in particular. They are very gentle metaphors; if I were pressed to interpret the way I have arranged my desk, I might realize there is something faintly religious about it, but life would be unlivable if that association jumped out at me every day. At the same time, subtle altars abound in our houses and offices. (That is my principal objection to Turner's book on women's altars: they exist everywhere, just under the level of consciousness.) The problem for some contemporary artists is how to make the faint perfume of religion into a theme—how to spell it out without ruining it. A few contemporary artists use subtle symmetries to evoke religious meanings, and many more evoke religious meanings without intending to. Like the quasireligious tornadoes in *Twister,* contemporary artworks are replete with religious themes that weren't thought of as religious at all.

Religious symbols and meanings can be altered, pared away, and finally evaporated. They can also be burned. Anselm Kiefer's burned books, which he has been making since 1969, are the art world's most famous examples of charred holy objects. Kiefer has not burned Bibles, exactly, but he has burned, stained, glued, soaked, and otherwise disfigured a large number of books. He makes books of photographs and then draws on them with chalk, paints with oils, covers the images with bitumen, and adds sand, clay, hair, and lead until the images are nearly, or completely, destroyed.[28] They have been widely imitated. Over the years I have seen dozens of burned books: it is almost a stage that artists have to go through if they are interested in books and specifically in the Bible. Last year a student of mine took sheets of paper on which she had made drawings and put them in the oven to char them. Then they were soaked in bleach, dipped in liquid nitrogen, bound into books, and then buried. A few weeks later she dug them up, untied them, and put the ruined and illegible pages

up on the wall. Another student gave me a book he had made: a Bible, encased in a welded iron frame so it can never be opened. It was his way of thanking me for a class in which I had argued that certain religious meanings are inaccessible in modern art. Ria's ungainly mass of poorly fired clay belongs in this same group. It was ruined as religion before it was fired, but the firing turned it into a wreck—more or less, I hope, what she wanted.

Ria's belief, her faith if she would put it that way, is that there must be a meaningful portion of older religion trapped inside the dogma, and that it can be found by discarding the useless practices of organized religion. But can dogma be burned away, leaving spirituality? Or is it all of a piece? The meaningful core might be hidden in the fustian trappings, but then again you might kill something if you burn it. I think Ria was wondering: can I reject the weekly observance of my parents' faith, retaining only a few images, and still keep the essential spirit of the religion?

This is a problem that has concerned anthropologists, linguists, and theologians as well as artists. Beginning in the 18th century, shortly before the origins of the Romantic movement, people began to theorize about the world's first religions, and the directions of their theorizing accord remarkably well with contemporary issues. At one time or another anthropologists have thought that the first religion was pantheism, fetishism, henotheism (the belief in family gods), ghost worship, and even monotheism. The 20th-century anthropologist E.E. Evans-Pritchard made a list of the candidates for the *Ur-Religion* (the prehistoric, primordial religion), including "manism, nature-mythism, animism, totemism, dynamism (*mana,* &c.), magism, polytheism, and various psychological states."[29] This search for the *Ur*-religion spread into linguistics; it was a concern of the great Sanskrit scholar Friedrich Max Müller, who spent a lifetime searching for evidence of monotheism in Indian religious writings. It could be argued that the 18th-century search for primordial forms of religion survives in the current belief that world religions harbor a common core of truth. (Every religion espouses the Golden Rule, as we were told in school.)

Among the post-Romantic explanations of religion are several that extend the search for the living core into the realm of psychology. Partly following William James, Evans-Pritchard promoted the idea that religion is at root a matter of "various psychological states." Such "emotionalist explanations" of religion hold that the indispensable element, the primordial core of religion, is a sense of awe or wonder.[30] Other anthropologists have attempted to explain religion as a social phenomenon, governed by societal conventions, which Émile Durkheim called the *mor-*

phologie sociale.[31] To the historian of religion Marcel Mauss, Inuit religion is a function of the season: the cold weather forces people together, creating the communal life that is essential for religion and promoting a "continuous religious exaltation."[32] Mauss's, James's, and Durkheim's social and psychological explanations of religion are another direction that is compatible with contemporary art, especially because they permit artists to discard even the transcendental moment and still address their work to religion.

Before I go on to the fifth and final story, I want to linger a moment to consider the problem more abstractly. The academic discourse that prefers talk about transcendence and reenchantment to talk about religion and belief is compatible with the claim, often made in art history, that contemporary art in its most serious and ambitious forms is a matter of the philosophy and theory of art and visuality. The idea is that religion is not only beside the point of contemporary art, but that it has actually become inaccessible to art. The historian Marcelin Pleynet, for example, has argued that theology is only artificially sustained in art, and that art's true source is no longer religion but philosophy.[33] A more provocative formulation is John Berger's idea that "art object, the 'work of art' is enveloped in an atmosphere of entirely bogus religiosity." That can mean two things: either art works are treated with misplaced reverence, or reverence is misplaced when art objects treat religious themes.[34] At first it seems these are separate problems. If an artist makes a sculpture in the shape of an altarpiece, it might be sacrilegious, or at least religiously incorrect, to worship it as if it were an actual altarpiece. But if the same work is put in a gallery, it will be treated with a respect that can look very much like reverence, or even worship. The two are aspects of the same problem, because they are both questions of worship.

Helen Chadwick's *Blood Hyphen* (1988) is a typical example. It was made by opening a ceiling in a church, so that the space divided into a dark upper portion and a lit lower story.[35] She aimed a laser beam at the floor, where she put a photograph of her own blood. The laser is reminiscent of the straight line painted in Renaissance depictions of the Annunciation: the Holy Spirit travels down the line from God to the Virgin. The blood is reminiscent of Christ's blood, and the brilliant upper floor contrasted against the spectral lower as the light of heaven to the unilluminated Earth. Even the title, *Blood Hyphen,* echoes the line, called a hyphen, between Christ's first and last wounds—between the circumcision and the wound in his side. Chadwick's piece has the elements of a sincere religious work, and it was even installed in a church. But knowing that it was an artwork—it was created for the London Edge International

Biennale—and knowing that it was not integrated into church services are enough to throw down a veil between *Blood Hyphen* and the blood of the Eucharist.

Is Chadwick's piece religious? Or would it be better to say it *refers* to religion, or uses religious themes, or—in the awkward expression preferred by art criticism—"references religion"? A good source for considering this problem is the exhibition called "Contemplations on the Spiritual" held in Glasgow. Five artists made artworks in and around churches, chapels, and synagogues. As part of the show Thérèse Chabot made what she calls "large-scale sacred gardens" in the Garnethill Synagogue and the Glasgow Cathedral, intended to "invite the visitors on a sort of journey or pilgrimage through various locations allowing them to reconnect with their inner self." Doilies, gloves, gauze, and flowers decorated the synagogue, along with a Star of David made of flowers. Alan Greenberg clothed the pillars of the cathedral cloisters in cotton velvet and put broken mirrors on the floor of the synagogue lobby. Jeffrey Mongrain hung an abstract "stone-like figure" outside the Lady's Chapel in the cathedral, and Jo Yarrington replaced stained glass windows with photographs of hands and parts of women's bodies.[36] The works all refer to religion, and some seem to conjure a renewed sense of religion; but it is very difficult to say more. I take it all the artists intended to "speak eloquently in sacred spaces," as the exhibition's curator says. But there is a difference between that and discovering, through art, how "venerable spiritual traditions touch the contemporary consciousness." The editor proposes both as the exhibition's main premise, as if they were equivalent or at least overlapping. But one is a matter of art referring to religion and the other is a question of spirituality, which has no necessary connection to art.[37]

One way to make progress on this problem is to consider the property of *sacredness*, the possession of religious value that causes an object to be "dedicated" or "set apart."[38] In Table 1, I list three classes of objects that can be considered as sacred: people, places, and things. In religious observance, the people might be rabbis, prophets, or shamans; the places might be temple grounds, altars, or ritual spaces; and the objects might be books, icons, sacrifices, or liturgical paraphernalia. Notice that this same schema also works for the art world. In that case the people would be artists, the places stages, museums, galleries, or installations, and the objects pictures or sculpture.

This simple arrangement can engender tremendous complexity because artworks can both symbolize sacredness and be examples of sacred objects. An image that signifies the sacred might remain secular (for

Table 1. Comparison of Sacredness in Religious Observance and in Art

Sacred object	Religious examples	Artistic examples
A person	rabbi, shaman	artist
A place	locus, temple ground	gallery, installation
A thing	text, icon, sacrifice	picture, sculpture

example, a picture of a cross in a newspaper) or it might be sacred while also signifying sacredness (as in an icon of the Madonna). The two modes, signifying and exemplifying, can mingle. Charmion von Wiegand's painting (see plate 28) is at one and the same time a sacred object and an object that tells us about the sacred. An art object can maintain a certain distance from sacredness, while at the same time both representing its subject as if it were sacred and presenting itself as a sacred object. Hence, the words in the right column of the table reconnect to the left-hand column, and the entire table turns on itself like a cylinder.

In philosophic terms, that is why it is not quite right to speak of religion *in* art, because the artwork and the religious image encompass one another. This simple fact permits an infinite regression of meaning, so that the artwork oscillates between being a sacred work of art and a secular work of the sacred. The postmodernist Victor Taylor has written a book about contemporary religion and art called *Para/Inquiry;* he refers to configurations of doubled and trebled meanings like the ones I am sketching here as "paralogies," "pararealities," "paradiscourses," "para Shoahs," and so forth. "Parasacrality," he says, is "the ultimate without centrality, distributed throughout the totality of phrases that comprise the universe," and the prefix "para-" itself is "the non-negatable image of a concept."[39] In a sad, poetic chapter on contemporary cemetery sculpture, Taylor considers sculptures of women with anchors (see figure 31). The anchor is a traditional symbol of religious faith because it reminds viewers that the body is anchored to the world even while the spirit looks upward; and because faith is itself an anchor, fixing the soul in place. Taylor says some of these figures appear content, and others anguished. The result is an "aporia," a state of indecision, a "rupturing of intelligibility."[40] The sculpted women are "liminal": caught between one state and the next, one world and the next—and caught, too, between the old faiths and the empty form of those faiths:

The figures are in transition from the body to the spirit, and neither expression—contentment, anguish—seems adequate to the resolution of the perpetual liminality here presented. The parasacrality of the cemetery emerges within this inadequacy as an aporia and an anguish over the step, the transition to the beyond.[41]

Taylor attempts to pin down the elusive feeling of abstracted, deferred sacredness in contemporary culture; it is a pervasive form of the same cylindrical conundrum of references I just explored. Given the entanglement of signification and exemplification, it can become hard to describe the religious (or "para-religious" or quasireligious) meanings of art directly or even clearly.

Fig. 31. *Figure of Faith with an anchor*. From Victor Taylor, Para/Inquiry: Postmodern Religion and Culture (London: Routledge, 2000).

Perhaps the impetus toward abstraction has been taken farthest by the artist Bill Viola. One of his projects involved recording the ambient sound inside the Duomo in Florence. Viola has said he was not interested in Catholicism, but in the hollowness of the sacred space. "It impressed me," he observed, "that regardless of one's religious beliefs, the enormous resonant stone halls of the medieval cathedrals have an undeniable effect on the inner state of the viewer."[42] Viola is a religious person, a practicing Buddhist with interests in Sufism, Christian mysticism, and Zen. But what, exactly, is religious about recordings of the ambient noise of cathedrals? It is a question no one quite knows how to answer.

Joel's Story Explained:
Unconscious Religion

I COME NOW TO JOEL'S STORY (HE IS THE STUDENT WHO MADE hundreds of pictures of an odd-looking heartlike object). Joel was really in the process of discovering a faith for himself, even though he did not even think of it in those terms. It could seem that artists like Betye Saar and Rose Frances are doing the same when they make altars, but I think projects like Joel's are fundamentally different because they are not conceived as religious projects at all.

Joel's work did not belong to any religion, it's true: more important, he did not understand it as religious or spiritual in any way. The reason I think it makes sense to speak of his work as religious is that it occupied some of the same places in his life that religion does in other people's lives. His heart shape was his constant companion, his solace, his obsession. It is Joel, even more than Ria, who exemplifies the place of religion in contemporary art.

Joel's work is also part of a history, although this time it's a history that apparently has nothing to do with religion. It is, I think, primarily the history of surrealism, woven together with the concept of the sublime.

Thomas Weiskel, a literary critic, describes the sublime as an essentially transcendental idea. (Weiskel is, in this respect, very much a part of the academic discourse that cleaves to words like "transcendence." In this case, the word is also appropriate because it is part of the history of the sublime.) The sublime has to do, Weiskel says, with finding something beyond the world as we experience it, something transmundane:

> The essential claim of the sublime is that man can, in feeling and speech, transcend the human. What, if anything, lies beyond the human—God or the gods, the dæmon or Nature—is matter for great disagreement.[1]

In the last three decades of the 20th century there was considerable interest in the sublime and its sister concept, the beautiful; in the 1990s every few months saw a new exhibition, essay, or book.[2] In academic writing the sublime remains near the center of discussions in literary theory, aesthetics, and art criticism.

The sublime is—among many other things—an opportunity for writers in the largely secular culture of the art world to speak about concepts that used to be studied only by theologians. Historically speaking, the proper venue of the sublime was Romantic painting and poetry. Friedrich's mountain ranges and bottomless abysses, his rainbows that seem to stretch forever from one end to the other, and his placid oceans that mirror scarlet sunsets: all that was directly and obviously sublime.

As time passed, those grand gestures began to seem unconvincing, and some 20th-century landscape painters tempered the scale of their sublime objects. They preferred cloud banks hiding distant views, and they muted the Romantics' blazing sunsets to evocative grays and roses. The volcanoes, primeval forests, icebergs, Niagaras, and deserts of early- and mid-19th-century Romantic painting gave way to more intimate and ambiguous views. Hedgerows hid views of the open prairie (in Blakelock, and before him in Inness); scattered backyards took the place of garden vistas (in Menzel, and earlier in David); small copses of trees substituted for an ancient oak forests (in Théodore Rousseau, and before him in Courbet). Those retrenchments, it could be said, mirrored changes in the philosophy of the sublime, from the full-blown Romantic concept to a more pessimistic or tentative version.

Neil Hertz, another literacy critic, has emphasized the "end of the line" quality of what he calls the "postmodern sublime": the sublime, he says, occupies a place at the end of thought, where thinking itself is nearly extinguished. Hertz illustrates his point using a painting by Gustave Courbet, depicting a stream flowing out of a cave (see figure 32).[3] The subject is starkly different from Friedrich's endless plains and panoramas because the view is cut off, ambiguously, by the mouth of the cave. In place of the thrilling infinity of Friedrich's paintings there is an uninviting darkness: possibly, therefore, a different kind of sublime.

Hertz considers the rocky stream bed and imagines places where a person might stand. He doesn't say that a view should imagine a stroll into the painting—that would be too literal an approach, one that doesn't pay attention to the fact that this is, after all, a painting—but he acknowledges that a viewer's eye is naturally attracted to stable places, places where, if this were real life, a person might stand. The rocks in the stream bed attract the eyes for that reason. In a more abstract vein, we can

Fig. 32. Gustave Courbet, *La Grotte de la Loue*. 1864. Washington, National Gallery of Art. Gift of Charles L. Lindemann, 1957.6.1.

imagine ourselves *as* those rocks, in the sense that the rocks "stand" in midstream and have a "view" into the cave mouth.

As he stands in front of the picture, Hertz occupies the position that Courbet once occupied when he painted it; and so, borrowing an expression from the art historian Michael Fried, Hertz calls his point of view the "painter-beholder." When he identifies himself with a position inside the picture—a rock, in this case—he then becomes a "painter-beholder in the picture."[4] The relation between the real viewer, outside the painting, and the focal point provided by the rocks can be depicted as shown in Diagram 3.

What interests Hertz is the way that the two viewers, the real one and the imaginary one "inside" the picture, form a pair. As "painter-beholder," Hertz drifts back and forth in imagination from his actual place outside the picture to his place inside the picture. An actual viewer will not always keep the difference firmly in mind; you don't always remind yourself that you're in a museum looking at a painting, sometimes you just drift, more or less consciously, into the painting.

Within the painting, there is another pair: the darkness of the rock

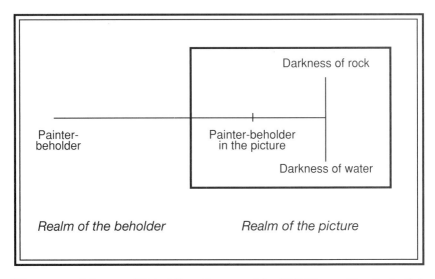

Diagram 3. Schema of Beholding, Suggested by Neil Hertz, *The End of the Line*.

and the darkness of the water. That pair mirrors the one formed by the viewer in front of the painting and the imaginary viewer, or viewing place, inside the painting. The second pair, the one within the painting, is shadowy and hard to keep in mind. The painted water and painted rock are dark and very much alike, and so is the difference between the "painter-beholder" and the "painter-beholder in the picture." This is a form of the postmodern sublime because there is no way to escape wholly into the picture, as there sometimes was in Romantic paintings. Instead the viewer is caught in a dead-end meditation on the *impossibility* of escaping.

This analysis has affinities to religious thought. Hertz's account answers a specific desire: to occupy and articulate, as far as possible, a place at the end of thought. Not all thought reaches its extinction in this beautiful, outlandish fashion. But for Hertz, Weiskel, and some other critics, the postmodern sublime is alluring because it fails: it offers no infinite vistas, only dark caves and black walls of paint. The postmodern sublime is a place where the exhausted mind digs among the last shards and fragments of meaning that might point toward something transcendental, even if pure transcendence, real sublimity, remains out of sight.[5]

I've elaborated Hertz's model somewhat and made it stand for a longer history than he intended. The postmodern sublime has become a cottage industry in literary criticism, and there are dozens of books on the sub-

ject that treat it in sometimes very different ways.[6] What I am extracting here is an emblematic moment in which the sublime is said to break down. The postmodern sublime experience ends in uncertainty rather than in pleasure, and it turns our thoughts back on themselves instead of freeing them—as Kant said—to measure themselves against the infinite.

An example of recent artwork that draws on this sense of the postmodern sublime is Tacita Dean, especially her *Disappearance at Sea II,* one of two films made inside the light of a lighthouse (see figure 33). In one version of the film, the lighthouse bulb is visible and so is the sunset on a distant coast. At one point the light from the lighthouse gently illuminates the far shore. The films are about an amateur sailor named Donald Crowhurst, who disappeared during an attempt to sail around the world in 1968. Dean's films draw on the postmodern sublime in very much the sense that Hertz proposes, in that they look out into a featureless ocean and give nothing secure in return. As in Courbet's painting, we are asked to look into, or at, an unrewarding stretch of blank ocean and to imagine our place, or lack of place, in such a landscape.

Disappearance at Sea II is an austere and cold artwork, in contrast to the actual story of Crowhurst, which was reported in the best-seller *The Strange Last Voyage of Donald Crowhurst.* In real life Crowhurst sailed back and forth in the south Atlantic, instead of heading for the Cape of Good Hope like the other sailors in the race. Slowly, as the months dragged on, he formed the plan of rejoining the racers as they completed their trip around the world and sailing back into England in triumph. To do that he had to lie about his position, claiming he was in the Indian Ocean when he was still zigzagging across the south Atlantic. The waiting,

Fig. 33. Tacita Dean, Disappearance at Sea II. 1997. Still from 16mm color anamorphic film. Courtesy Marian Goodman Gallery, New York.

the isolation, and the strain of his elaborate lies wore him down, and eventually he had a psychotic break. A journal he kept, called *Philosophy,* records his strange fantasies. The journal was recovered when his boat was found. Crowhurst himself had disappeared, and it was assumed he had drowned himself. In his final days, Crowhurst had argued himself into a state of mind in which he could become God. The entries are sometimes pathetic, especially when he seems to be reasoning with himself about the "game" he was playing: "Reason for game unsure. If game to put everything back? Where is back?"[7]

Dean has been fascinated by Crowhurst for a number of years, and she has also documented the boat itself, which lies rotting near a beach on Cayman Brac in the Caribbean.[8] The contrast between Crowhurst's diary and Dean's films and photographs is a litmus test of the strengths and limitations of the postmodern sublime. *Disappearance at Sea II* is ravishing, mysterious, quiet, hypnotic, and very, very simple, and Dean's book, *Teignmouth Electron* (the name of Crowhurst's boat) is austere and meditative. Crowhurst's diaries are entirely different. He was not an especially good writer or thinker, and his reflections before his insanity are frequently dull and self-absorbed. He is also funny, pathetic, messy, and even, in his final psychosis, boring. Sublime art, including its postmodern varieties, pays a high price for its ecstatic view of the world: it leaves out all the world's bumps and politely ignores its low comedy. Dean's film is moving and supremely well controlled: inhuman, in a sense. Looking at *Disappearance at Sea II,* it would be hard to guess why Crowhurst has become something of a folk hero.

Not all contemporary writers who want to revive the sublime think as Hertz does, and there is a large literature on the old-fashioned Romantic sublime. But the disappointment and the modesty of Hertz's and Weiskel's sublime is in tune with the moment. When the sublime is revived in all its old-fashioned glory, the result is "starving artist" paintings, the ones with the rainbow colors and tiny awestruck figures standing on precipices looking out at exaggerated Grand Canyons with rainbows erupting volcanoes in the background. To keep the Romantic sublime from choking on its own luxurious diet, it seems necessary to narrow its scope and keep it terse.

There are as many kinds of postmodern sublime in painting. Ed Ruscha has painted sublime, Albert Bierstadt–style mountains, stenciled with slogans that deflate their sublime potential. They are funny, terse, ironic, and sublime in a postmodern sense. Joel's funny-looking heart shape is not impressive like Ruscha's mountains, or austere like Dean's video, but it is a similarly reduced sublime. It is all Joel could manage, all he needed.

Anything more demonstrative or optimistic would have seemed like false trumpeting, but anything less evocative or enchanting would have seemed flat. The little hearts are sublime—but they are a weakened and tentative sublime: a postmodern sublime.

The sublime comprises a more intricate history than I can recount here; there is still no adequate book on its history. To describe surrealism, the other component of the intellectual history that leads to Joel's work, I need to return to Hegel. In the *Aesthetics*, published in 1831, Hegel divides art into three phrases: symbolic, classical, and romantic. The first stage produced images of gods that are monstrous, obscure, and unpredictable, such as non-Western animal gods and totems. The second, classical phase replaced the arbitrary symbolic forms with perfectly realized human forms, as in Greek and Roman art. In the third phase, the romantic, art became thoroughly infused with spirit and no longer needed the confining symbolic forms of animal-shaped or anthropomorphic gods.

Hegel subdivides the first, symbolic phase into three subsidiary phases:

- In the first stage of symbolic art, no one perceives a discord between the symbolic shape and the idea: the elephant-shaped Ganesha is simply accepted for what it is and taken as a beneficent deity.

- The second stage, Hegel says, is the sublime: people are bewildered and astonished by the appearance of the divine. There is a revelation that the divine, the absolute as Hegel calls it, is inaccessible, but can be understood through the symbolic form. The Shiva lingam, with its disputed iconography, would be an aptly Hegelian example.[9]

- In the third stage people understand that the symbolic shape is arbitrary, but they accept it because they realize no symbol can be adequate to their idea. The Jain sauvastika (see plate 24) would be an example: it is a nonrepresentational symbol and is known to be such.

Hegel's idea is that art moved through the symbolic and into the romantic phase, where artists from Francken and Friedrich to Ria work by creating fluid images of divinity without awkward fixed symbols. But not all art took that path. Some remained behind. In Hegel's terms, Picasso's interest in African and Oceanic masks would be an example of a reversion to symbolic art. The most important modernist example of Hegel's symbolic art would be surrealism, where as Besançon puts it, art "offers itself as a religious object in quest of an enigmatic content."[10]

From the perspective of a Hegelian schema, surrealism largely remains within the symbolic phase. Joel's odd heart shape is a perfect and typical example of an "obscure" and "monstrous" object (two of Hegel's favorite words). The heart shape points darkly to something beyond itself, an idea so wonderful and otherworldly that it can only be represented by a weird invented shape. Whatever Joel was thinking of, it was not a heart-shaped idea. His hundred false hearts move back and forth among Hegel's three stages of symbolic art: at one moment their obscurity is just right (the first stage); then they light up with incandescent strangeness (the second, sublime moment); and then they seem hopelessly inadequate to whatever Joel might have been thinking (the third phase).

Surrealism and the sublime are two links in a chain that tether Joel's work to the history and philosophy of art. He was attracted to his funny-looking heart objects because abstractions, landscapes, and other kinds of painting didn't seem expressive enough. That is a fundamentally surrealist concern, and it can be elucidated with the help of Hegel and the sublime.

Other artists akin to Joel take surrealism, "symbolic art," and the sublime in other directions, especially toward sexuality and medicine. In contemporary art, pictures of the body (including hearts) and of sex are infused with meaning that they did not have in the 19th century. It is not easy to measure the effect, but it is telling that one of the principal preoccupations of academic art history has become the study of gender and sexuality in art. At one extreme, sexuality and gender can become central to the work, and even take on some of the meanings that were once the province of religion. Dave Hickey, an art critic, illustrates an essay about the new sense of beauty with photographs from Robert Mapplethorpe's *X Portfolio,* the most explicit and violent pictures Mapplethorpe ever made. Power, in these images, is centered on sexuality.

The photographer Joel-Peter Witkin is another example. He says that what he is after in his photographs of circus freaks, fetuses, cadavers, and congenital deformities is a sense of sexuality that approaches the sacred. By avoiding normalcy he hopes to approach an inner, mystical revelation of the sacredness at the center of human life. It is essential to his project that he avoids institutional religion. One of his photographs is of a *penitente,* a group in New Mexico who practices crucifixions. Other photographs show sadomasochistic scenes that are christological in tenor; but Witkin only makes religious images when he is emulating Old Master paintings, never when he is after a sense of the sacredness of sexual life. (Witkin is also a good example of the idea of cracking the shell of religion to reveal the true spirituality hidden inside it.) As Witkin puts it, "the

sacred appears ... linked to the erotically profane."[11] The garish excesses and perversities in his photographs are presented in a gorgeous elaborate arrangement and printed in fastidious, old-fashioned ways, as if the strength of his "sacred" subject matter requires an equally powerful technical polish.[12]

Even at this extreme, where distortions of normalcy are taken to harbor hidden meaning, there is a connection with Joel's hearts. I don't think his paintings of the little heart are sexual, but they are sensual, full-blooded, and ripe. There is something a bit obscene about them. They don't disguise the fact that they are organs. His work is also similar to contemporary artworks that are based on biology texts. Such art uses internal organs, microorganisms, worms, and microscopic organelles as inspiration. Other students of mine have made paintings based on photographs of organs, histological samples, sperm and eggs, and cell division. This particular interest in biology can be traced to the late 19th-century painter Odilon Redon, who admired microscopic forms. In the 1940s Barnett Newman painted and drew a series of pictures showing seed pods, rhizomes, and underground growth. Newman was following interests developed by surrealists such as Jindrich Styrsky and Max Ernst. After the 1960s such work would become commonplace.

Sexuality, biology, and the spiritual have been mixed now for at least a century. In 2000, a student of mine made a video of herself smoothing and caressing her friend's placenta in the hospital.[13] In the video, she slides the placenta back and forth across a steel hospital cart, while her friend watches from a bed in the background. There is no voice-over, just ambient sounds. Toward the end her friend says, "I think that's enough now." The video was surprising, to say the least, but it was also quiet and reverential and wholly compatible with the genealogies I have been sketching.

Joel's work had affinities with the historical lineages of the sublime, of surrealism, and of the revelatory body. He was, I think, unaware of those connections, although he could easily have utilized them. But he was also unaware that they were the components of an unconscious religious practice. He certainly would have denied any spiritual or religious purpose in his work. His little heart shapes seemed "introverted, anti-artistic, anti-intellectual, apolitical, sentimental, dualistic, ascetic, and in many ways masochistic," as Michael Stoeber has said of the late medieval mystic Meister Ekhart.[14] He was—and perhaps still is—a truly religious artist.

Some Words
to Describe Spiritual Art

I want to bring this little book to an end by proposing some ideas and words that can help give voice to art like Joel's and Ria's. Rehema's NRM-inspired art already has a flourishing vocabulary, and Kim's religious work and Brian's antireligious work have all of religious discourse on which to draw. But for artists like Joel and Ria it seems there is no acceptable way of talking about what makes the work religious or spiritual. At the beginning of this book I said my principal purpose is to write in such a way that people on the far ends of the question of religion and art might be able to read without taking offense or feeling irreparably misrepresented. My second aim is to find words to help younger artists and their teachers speak about religious meanings. This section is meant to make a start in that direction by introducing just a few words and theories that I have found helpful in talking to artists.

In a sense many of the ideas I have explored in this book could be used to coax conversations about spirituality from reticent artists and teachers. The sublime and postmodern sublime are useful concepts, based as they are on an acceptably secular discourse inaugurated by Kant. Surrealism, in the particular way that I have described it, is also helpful. It too can be a way of bringing up religious ideas without straying into theology. Still, it would be best to have words that are indigenously religious.

The word *numinous* is an interesting candidate, and it may be the closest to a one-word definition of the spirituality that informs some current visual art. It means the sudden, overwhelming, and nonverbal presence of the godhead, surpassing all comprehension or understanding: the immediate revelation of holiness.[1] The word was coined by the Protestant theologian Rudolf Otto in an important book called *The Idea of the Holy*, which was an attempt to blend Kant's philosophy with Otto's conviction that the heart of religion is a nonverbal experience. *The Idea*

of the Holy is the most concerted meditation on the idea that religion has to be excavated, as in Ria's art, to access what matters; and Otto is one of the best modern thinkers on the idea that whatever counts as truly spiritual cannot possibly have an adequate name.

Mysticism itself is another concept that can occasionally be used without damaging conversations about art. Mysticism has tended to assert itself in periods when there is a sense that organized religion is ossifying or becoming decadent, and ours is conceivably such a period. Art is mystical, properly speaking, when it involves an intimate, personal, or private connection with something transcendental.[2] This is the classic definition of mysticism: a mystic mistrusts rationality and depends on assertion, as Joel did. Mysticism is also close to spirituality as I defined it at the beginning: mysticism is concerned with an intimate and incommunicable experience of transcendence. With the remnant of religious experience, Renaissance mystic Jakob Böhme is an eloquent example of the ineloquence of mysticism. His books can be read as a failed but lifelong attempt to describe his own intense and sudden experience of God, which happened one day when he was at work. In *Aurora* and other books, that initial revelation unfolds but remains essentially dark and inadequately explained.[3] Lessons could be taken from Böhme on how personal, spiritual elements in art can be talked around, but never at or even through.

The numinous and mysticism can be helpful concepts, but in my experience they are both tainted by their association with the major Western religions. I have talked to artists who have shied away from them because they sound too serious or institutional. The best option, I think, is to find concepts that are at once religious and also removed from recognizable affinities with organized religion.

There is some talk of atheism and agnosticism in the art world, but I find those labels are inappropriate. Few contemporary artists who avoid thinking about religion are rationalists like the 18th-century Deists or the 19th-century atheists, and there is little impetus among artists I have known to discard revelation in favor of logic. Though people who are not affiliated with religious groups like to call themselves agnostics, few follow Thomas Huxley's original definition of agnosticism, according to which one must not assert something unless there is "evidence" that will "logically" support it. Huxley was a determined rationalist, declaring that agnostics must "deny and repudiate" the "immoral" doctrine that people should believe certain things "without logically satisfactory evidence."[4] Nor would any nonreligious artists I know bother with refuting the three medieval proofs of God's existence.[5]

It may seem the optimal solution is to remain silent about what is tran-

scendent. Weiskel said as much in the passage I quoted, and more famous writers from St. Augustine to Wittgenstein have proposed similar solutions. Art aside, this answer makes good sense. The only reason I am not content with it is that the subject here is conversation and the possibility of extending and altering conversations about art. With that in mind I propose the best answer I know, apophatic or negative theology (*theologia apophatike*).[6] It was inaugurated by the so-called Dionysius Areopagiticus, whose *Mystical Theology* finds God—or rather, finds what God is not—by paring away positive attributes and their opposites until nothing remains except an unknowable negative term.[7] Every affirmation, *kataphasis,* can be undermined, in this mode of reasoning, by an *apophasis.* The result is a way of thinking that refuses to remain silent about what is transcendent. It also refuses to accept any division between what can be said (for example, God is in heaven) and what cannot be said (that God has such-and-such an appearance).[8] The division itself is broken down by apophatic reasoning, because the apophatic writer refuses both the sayable and the unsayable. The result is an evanescent state of mind: the sense of not knowing, and not knowing what is not known, has to be continuously renewed by fresh doubt. It is a magnificent way of thinking—really, trying not to think—and it can have tremendous appeal for people who are uncomfortable saying anything about religion or even transcendence.

Negative theology has been reinvented in various times and places that at first seem unrelated. The poet Czeslaw Milosz reports that in 19th-century Russia there was a sect of "hole worshipers," people who drilled holes in their walls and prayed to them, repeating the words "My sacred hole, my sacred hut."[9] In hole worship the image or cult statue was replaced by "negative space" or perfect absence. A third starting point for negative theology is Gnosticism, and in particular the Gnostic concept of the "alien god," the absent "Other." (Gnosticism is the origin of the notion of the "Other" that is widely employed in contemporary philosophy of religion.) In Gnosticism, the "alien god" is permanently hidden from the world and can only be known by negative attributes.[10]

It would also be possible to explore negative theology beginning with Indian texts. In the Upanishads, "negative dialectics" (नेति नेति, *neti neti*) is the method of invoking the holy by continuously negating whatever proposals might be made about it.[11] In the *Kena Upanishad,* the speaker is concerned at first to say what Brahman (the divinity) is not: "The eye does not go there," he cautions, "nor speech, nor mind."[12] The Brahman is said to be *neti neti,* meaning for example neither form nor formlessness, but a third, unnamed, principle that does not admit contradiction.

Neti neti is *bhedad-anyah* मेदाद् य "other than difference." In the Upanishads, the Brahman is ultimately *nirguṇ* (निर्गुण, devoid of all qualities).[13] There are various apophatic or negative paths in the Upanishads. The *Mandukya Upanishad* proposes four stages to consciousness. The fourth is the one that "does not perceive the internal, does not perceive the external, does not perceive them both; and it is not a lump of consciousness—it is neither a consciousness nor its absence." Natalia Isayeva, who has made one of the closest studies of this four-stage path of consciousness, proposes that the final stage is like a "vibration," a "pulsation" (*spanda, sphutarra*) that "gradually condenses and darkens in its descent" and comprises the "foundation for the evolution of the world": in other words, the highest state of consciousness is a kind of shimmering that provides the energy and form for understanding everything else.[14] It is the apotheosis of apophatic thinking.

All these strands—Greek negative theology, the Gnostic alien god, Russian hole worship, Indian negative dialectics—can be read apart or together to elucidate practices that would otherwise go unnoticed and unnamed. In apophatic theology a central metaphor in negative theology is the biblical story of Jacob's ladder. As Jacob sleeps, he sees angels climbing up and down a ladder that stretches up to heaven. Angels coming down are like metaphors for God, such as Goodness, Virtue, and so forth, and angels climbing up are like hypotheses about God stripped away one after another. Dionysius says that knowledge of God has to follow the departing angels because reason and understanding desert us when we look toward God:

> Ascending, we say, that It is neither soul, nor mind, nor has imagination, or opinion, or reason, or conception; that It is neither expressed, nor conceived; It is neither number, nor order, nor greatness, nor littleness ... nor has power, nor is power ... neither lives, nor is life ... nor Spirit ... nor Sonship, nor Paternity; nor any other thing that we can know ... nor any non-existing nor existing things, nor do things existing know It, as It is; nor does It know existing things ...[15]

To think about "It" is to enter into the "brilliant" or "mystic gloom" of the agnosia, the state of absolute, helpless unknowing. Dionysius's brilliant gloom is the ancient source for the popular account in the 14th-century text known as *The Mysticism of the Cloud of Unknowing*.[16] The Jacob's ladder metaphor and the chain of apophatic and kataphatic judg-

ments are interesting models for certain moments in modernism that depend on successive negations of earlier positions. Without pushing the parallel, I would suggest that the dissolution of the art object in conceptual art and the progressive narrowing and literalization of the object in minimalism have more than a passing resemblance to the long Western history of restrictive negative judgments. I hasten to add that apophatic theology is not a model for explaining minimalism or conceptual art, both of which have well-developed discourses and are not in need of such broad and speculative explanatory schemes. But the wider cultural affinities of practices such as minimalism and postminimalism may become relevant when it is a matter of finding words to link fields as large, and as deeply rooted in history, as "art" and "religion."

Inevitably there are postmodern complications of negative theology. Mark C. Taylor meditates on "something like a nonnegative negative theology that nonetheless is not positive."[17] More logically, he follows the French writer Maurice Blanchot in thinking that the best way to name God is to imagine Him as a "*failure* of language." In that case, "the 'name' of this failure is the unnamable and the pseudonym of the unnamable is 'God.'" Or, in Blanchot's words, "The name *God* signifies not only that what is named by this name does not belong to language in which this name intervenes, but that this name, in a manner difficult to determine, would still be part of language even if the name were set aside."[18] That may seem hopelessly abstract, but it is only the result of taking people like Dionysius seriously. If God is whatever cannot be named when everything else can be, then God must be similar to what Blanchot and Taylor describe.

I think these terms or others like them are necessary if we are going to begin talking seriously about religion in current art. On the other hand, it is just as important that we don't plunge into a lugubrious discourse about absences and failures of language. At the end of his book on art and religion, Taylor reproduces ones of Anselm Kiefer's altered photographs, showing a desert (see figure 34). The photo has been overpainted and stained, and a small string noose hangs from the top edge. A desert road crosses the composition. Taylor writes:

> On the far side, the Way disappears into, or appears out of, a vanishing point. On the near side, the Way fades into a void. No one follows this way. The desert is deserted—completely deserted. There is no resurrexit here or elsewhere. Only Ash . . . Ash . . . Ash . . . Night . . . Night-and-night.[19]

Fig. 34. Anselm Kiefer, *Flight from Egypt*. 1984–85. Museum of Modern Art. The Denise and Andrew Saul Fund (117.86). © Digital Image © The Museum of Modern Art/Licensed by SCALA / Art Resource, NY.

The rhetoric of disappearance, endings, and vitiated resurrection is jus-
tified to some degree by the image. But Taylor turns the image's clear sym-
bols into a paean for hopelessness:

> To be opened by the tears of art is to suffer a wound that never heals.
> "This experience," Blanchot explains, "is the experience of Art.
> Art—as images, as words, and as rhythm—indicates the menacing
> proximity of a vague and empty outside, a neuter existence, null,
> without limit, sordid absence, a suffocating condensation where
> being ceaselessly perpetuates itself as nothingness."
>
> The end of art: Desert … Desertion … The errant immensity of
> an eternity gone astray is the desert in which we are destined to err
> endlessly.[20]

It is true that Kiefer's picture is immoderately apocalyptic. The desert is
bleak, and the road (Taylor's "Way") does fade into "a void," if only
because the print has been overexposed. The streaks of paint are flat and
affectless, and the poison pool that replaces the glowing Heavens is cor-
uscatingly gorgeous. The picture practically yells *despair*.

The question I would ask of Kiefer's work and Taylor's meditations
on postmodern faith is their *difficulty*. If this is an image of inescapable
despair, why is it so lovely? If these ideas are at the end of the line of
religious thinking and depend on difficult texts by Jacques Derrida,
Emmanuel Levinas, Maurice Blanchot, and Edmond Jabès, then why is
the writing so fluent, so *pretty*? The ease of the prose and the fluency of
the image making are not commensurate with the difficulty of the ideas.
In fact a number of other painters made similar pictures before Kiefer.
Max von Moos's *Götterdämmerung* (*Twilight of the Gods,* 1959) is an
apocalyptic landscape in which the heavens spill down on a ruined
earth.[21] Von Moos splashed and smeared his paint just as Kiefer did; his
picture is just as much disillusioned with ordinary brushwork and just as
enamored of empty landscape. *Götterdämmerung* is also a lovely image
because it is easy to make images of lovely desolation using chemical
spills—Sigmar Polke is another example.[22] The experience of despair and
the impossibility of redemption are anguishing, and they are not well
served by texts or images that are this easy, this decorative.

I take Taylor as an example of what is called postmodern theology
because he applies his thought to painting, but he is only one of a number
of writers who have reformulated negative theology to fit it to contem-
porary poststructural religious criticism. There have been studies of
Jacques Lacan's theology and a number of books on Derrida's relation to

religion, including books by Derrida himself.[23] John Caputo has written extensively on the possibility of a poststructuralist sense of religion.[24] If I don't follow these paths, it is because none has so far had much effect on contemporary discourse on art. Some of the most important thinking on religion is taking place in such venues, but it does not represent the current state of visual art outside a narrow university culture.[25] Whatever visual art will be eventually judged to best embody the state of theology at the beginning of the 21st century, I doubt it will be Kiefer's, Pohlke's, or von Moos's. So I will close instead with an example from a very different corner of culture.

The critic Slavoj Žižek, whom I quoted on the subject of Marx's *Communist Manifesto,* has a quirky and brilliant analysis of the Japanese hand-held electronic game called the *tamagotchi,* which was popular in the 1990s (see figure 35). Each *tamagotchi* had a little screen showing an imaginary pet. By pressing buttons the electronic animal could be fed, entertained, and exercised. The animal could also signal it was hungry or thirsty, or wanted to play. If the wrong buttons were pressed, or the owner ignored the animal's entreaties, it would die. Žižek says that "*God Himself is the ultimate tamagotchi,* fabricated by our Unconscious and bombarding us with inexorable demands." *Tamagotchi,* he thinks, is a "purely virtual" entity that

> lays bare the mechanism of the believer's dialogue with God. . . . The charm of this solution resides in the fact that (what traditional ethics regarded as) the highest expression of your humanity—the compassionate need to take care of another living being—is treated as a dirty idiosyncratic pathology which should be satisfied in private, without bothering your actual fellow beings.[26]

It goes without saying that *tamagotchi* is a form of art: popular art, certainly, but still art: a little hand-held interactive movie, to be precise. Žižek's outrageous analysis shows just how far it is necessary to go—around the world, literally and theologically—to reconnect art and religion. But if I have to talk about the *tamagotchi* to begin a conversation about art and religion, I will be glad to try.

Fig. 35. Tamagotchis. Top: four tamagotchi. Top right: white/orange Mesut-chi (Bunkotchi with Tsubutchi); top left: white/green Osutchi (Bunbutchi with Tsubutchi); bottom left: yellow/black P2 (Mimitchi); bottom right: clear blue P1 (Ginjirotchi). Bottom: the "life cycle" of a tamagotchi (Ocean Tama, U.S. version). 1998. Photo and graphic courtesy of H. Kat Edelin.

Conclusions

IT HAS BEEN A CURIOUS EXPERIENCE, WRITING THIS LITTLE BOOK. Now that I am finished, my thoughts turn back to my day job and the many things I have to do—write lectures, teach classes, finish essays. As I think of those responsibilities, I realize none has anything to do with religion or spirituality. A university in California has invited me to talk about science and art; another has proposed the subject of the future of museums. My teaching for the coming year covers the usual issues of contemporary art—visual theory, methods of writing art history, postminimalism. Religion has nothing to do with them, and I won't be surprised if I don't mention religion even once during the course of the year. Clearly there is something wrong with that situation. Religion is so much a part of life, so intimately entangled with everything we think and do, that it seems absurd it does not have a place in talk about contemporary art.

I have tried to show why committed, engaged, ambitious, informed art does not mix with dedicated, serious, thoughtful, heartfelt religion. Wherever the two meet, one wrecks the other. Modern spirituality and contemporary art are rum companions: either the art is loose and unambitious, or the religion is one-dimensional and unpersuasive. That is not to imply the two sides should maintain their mutual mistrust, but that the talk needs to be very slow and careful.

I would have loved to end this book with a prescription. I could have said, as sociologically minded writers do, that religious art and fine art are equal but different, so that there is no particular problem with the nonreligious nature of much current art. Or I could have proposed, as some art historians do, that religion is simply absent from much of contemporary art, and objecting to that absence amounts to objecting to the cultural condition in which we find ourselves. Or I could have argued that religious meaning is interwoven in all of modernism whether it is spoken of or not. Or I could have promoted some kind of mysticism or spiritu-

ality to take the place of religious talk. I could even have followed the lead of conservative politicians and religious spokesmen and said that contemporary art is godless and in need of systematic censorship and renewed faith.

None of those solutions addresses the genuine difficulty of the subject. It is impossible to talk sensibly about religion and at the same time address art in an informed and intelligent manner: but it is also irresponsible not to keep trying. To paraphrase the passage from Blanchot I quoted earlier: the name *God* does not belong to the language of art in which the name intervenes, but at the same time, and in a manner that is difficult to determine, the name *God* is still part of the language of art even though the name has been set aside.

That is the stubbornness and challenge of contemporary art.

Notes

Preface

1. Elkins, "From Bird-Goddesses to *Jesus 2000:* A Very, Very Brief History of Religion and Art," *Thresholds* 25 (2002): 75–83, especially the section "Caroline Jones Responds," ibid., 81–83.

The Words *Religion* and *Art*

1. It is hard to sound neutral in defining a part of life as large as religion; I do it reluctantly in order to get the argument going. I have tried, in this definition, to name just the features of religion that are at once universally agreed-upon (my definition is adapted from several dictionary definitions) and pertinent to the themes in the book. I thank Frank Piatek and David Morgan for their responses to this issue.
2. Spirituality as I intend it here can also be linked to what the art historian David Morgan calls the "spiritualized response to art," the search for *innerlichkeit* and *innere Empfindung* in art. Morgan traces this through Romanticism to Winckelmann's reading of the Laocöon, which Morgan finds is infused with 18th-century "Pietist spirituality." If I do not follow this genealogy here simply because it has become so diluted and pervasive that it would be difficult to distinguish interpretive agendas that effectively oppose it. I thank Morgan for sharing his unpublished manuscript "Toward a Modern Historiography of Art and Religion," forthcoming in *Reluctant Partners: Art and Religion in Dialogue,* edited by Ena Giurescu Heller (New York: The Gallery at the American Bible Society, 2004).
3. Bourdieu, *Distinction: A Social Critique of the Judgment of Taste,* translated by Richard Nice (Cambridge, MA: Harvard University Press, 1984).

A Very Brief History of Religion and Art

1. For a color photograph and brief discussion, see Vincenzo Nicola et al., *The Christian Catacombs of Rome* (Regensburg: Schnell und Steiner, 1999), 124–25; for background see Paul Finney, *The Invisible God: The Earliest Christians on Art* (New York: Oxford University Press, 1994).

2. Andre Malraux, *La Musée imaginaire de la sculpture mondiale* (Paris Gallimard, 1952–54).

3. Hans Blumenberg, *The Legitimacy of the Modern Age,* translated by Robert Wallace (Cambridge, MA: MIT Press, 1983); Hans Belting, *Likeness and Presence: A History of the Image before the Era of Art,* translated by Edmund Jephcott (Chicago: University of Chicago Press, 1994); Mark Lalonde, *Critical Theology and the Challenge of Jürgen Habermas: Toward a Critical Theory of Religious Insight* (New York: P. Lang, 1990).

4. Marx's phrases are from *Critique of Hegel's Philosophy of Right* (1844), translated by Annette Jolin and Joseph O'Malley (Cambridge: Cambridge University Press, 1972).

5. Slavoj Žižek, *The Spectre Is Still Roaming Around! An Introduction to the 150th Anniversary Edition of the Communist Manifesto* (Zagreb: Arkzin, 1998), 72.

6. The secularization of current studies of iconoclasm is acknowledged by Bruno Latour, in *Iconoclash: Beyond the Image Wars in Science, Religion, and Art,* edited by Bruno Latour and Peter Weibel (Cambridge, MA: MIT Press, 2002). See my review, "Visual Culture: First Draft," *Art Journal* 62, no. 3 (2003): 104–7.

7. Personal letter from David Morgan, May 20, 2002.

8. Willaim Hood, *Fra Angelico at San Marco* (New Haven, CT: Yale University Press, 1993); Georges Didi-Huberman, *Fra Angelico: Dissemblance and Figuration,* translated by Jane Todd (Chicago: University of Chicago Press, 1995).

9. For other Renaissance examples see John Shearman, *Only Connect ... Art and the Spectator in the Italian Renaissance* (Princeton, NJ: Princeton University Press, 1992); and Paolo Berdini, *The Religious Art of Jacopo Bassano: Painting as Visual Exegesis* (Cambridge: Cambridge University Press, 1997).

10. Eileen Reeves, *Painting the Heavens: Art and Sciences in the Age of Galileo* (Princeton, NJ: Princeton University Press, 1997). My review, in *Zeitschrift für Kunstgeschichte* 62 (1999): 580–85, takes up this point.

11. Leo Ewals, *Ary Scheffer, 1795–1858* (Dordrecht: Waanders, 1995).

12. The painting is in the Musée d'Orsay. I thank Marc Gotlieb for bringing my attention to it. Gérôme is still awaiting contemporary treatments, see Scott Watson, "Jean Léon Gérôme (1824–1904): A Study of a Mid-Nineteenth Century French Academic Artist," MA thesis, University of British Columbia, unpublished; available on microfiche (Ottawa: National Library of Canada, 1997).

13. Albert Boime, *Thomas Couture and the Eclectic Vision* (New Haven, CT: Yale University Press, 1980).

14. I thank David Morgan for bringing these religious affiliations to my attention. See Morgan, "The Cosmology of Philip Otto Runge and Its Influence on His Interest in the *Gesamtkunstwerk,*" MA thesis, University of Arizona, 1984 (Ann Arbor, MI: University Microfilms, 1985).

15. I owe these two paragraphs, including the information on the artists' religious affiliations, to David Morgan, although the conclusion I draw is my own.

16. This is the subject of my "A Hagiography of Bugs and Leaves: On the Dis-

honesty of Pictured Religion," *Journal of Information Ethics* 2, no. 2 (1993): 53–70, reprinted in *Religion and the Arts* 1, no. 3 (1997): 73–88.

17. *Van Gogh and Gauguin: The Studio of the South,* edited by Douglas Druick and Peter Zegers (Chicago: The Art Institute, 2001). Compare Lauren Soth, "Van Gogh's Agony," *Art Bulletin* 68 (1986): 301–13, especially 309 on the "essentially religious nature" of the painting.

18. For Munch see *Edvard Munch: Psyche, Symbol, and Expression,* exh. cat., edited by Jeffrey Howe (Boston: McMullen Museum of Art, 2001). I thank Thomas Sloan for this reference.

19. Celia Rabinovitch, *Surrealism and the Sacred: Power, Eros, and the Occult in Modern Art* (Boulder, CO: Westview Press, 2002). I thank Celia Rabinovitch for correspondence on the subject of her book; the suggestion that her work is "anthropological" is hers.

20. H.H. Arnason, Marla Prather, and Daniel Wheeler, *History of Modern Art,* 4th ed. (New York: Harry N. Abrams, 1998).

21. The same observation could be made about modern classical music, from Arnold Schönberg onward. There are exceptions, such as the stupendous work of Olivier Messiaen, a devoutly Catholic mystic and devoted amateur ornithologist, but the majority of modern classical music is made and discussed in secular terms. See *Messiaen's Language of Mystical Love,* edited by Siglind Bruhn (New York: Garland, 1998), and *The Messiaen Companion,* edited by Peter Hill, who has also recorded some of the best versions of Messiaen's piano music (Portland, OR: Amadeus Press, 1994). Messiaen's posthumous theoretical opus, which will link his ornithology with his music, is slowly appearing: *Traité de rhythme, de couleur, et d'ornithologie* (1949–1992), 7 vols. (Paris: A. Leduc, 1994–).

22. Paul VI notes that classical perfection, esthetics, "la dignità intuitiva della forma," "pensiero chiaro," and other qualities are no longer those of contemporary society, and that modern artists have tended to substitute psychology for aesthetics; but that does not mean that the art does not hold up a true mirror to contemporary society. Paul VI, "Discorso di Paolo VI in occasione dell'inaugurazioe della Collezione di Arte Relgiosa Moderna nei Musei Vaticani," www.vatican.va/holy_father/paul_vi/speeches/1973/, accessed December 29, 2003.

23. For Chris Ofili's *Holy Virgin Mary* and Andres Serrano's *Piss Christ,* see Carol Becker, "Brooklyn Museum: Messing with the Sacred," *Surpassing the Spectacle: Global Transformations and the Changing Politics of Art* (Lanham, MD: Rowman and Littlefield, 2002), 43–58.

24. Helena Kontova and Massimiliano Gioni, "Christian Jankowski," *Flash Art* 223 (2002): 74–76; and M. Vincent, "Global Art—Christian Jankowski," *Art Monthly* 271 (2003): 17. Video stills are available at www.boilermag.it/gallery/ChristianJankowski. I thank Ayanna McCloud for a discussion of Jankowski.

25. An example of a critic sympathetic to art critical of religion but less interested in sincere believers is Eleanor Heartney, "Blood, Sex, and Blasphemy: The Catholic Imagination in Contemporary Art," *New Art Examiner* 26, no. 6 (1999): 34–39. I thank Anne McCoy for correspondence on this point.

26. *Divine Mirrors: The Virgin Mary in the Visual Arts,* edited by Melissa Katz

and Robert Orsi (Oxford: Oxford University Press, 2001), illustration on p. 7, credited to Guss Wilder III.

27. I would not correlate this with the well-publicized statistics on the frequency of religious observances in America as opposed to Europe. Those statistics are hard to interpret: for example, the percentage of people attending church at least once a month in the 1990s was 55 in the United States, but 8 in Russia, 17 in France, 74 in Poland, and 88 in Ireland, each one for very different reasons. See Rodger Doyle, "By the Numbers," *Scientific American* (July 1999): 25.

28. *Jesus 2000,* special issue of the *National Catholic Reporter,* December 24, 1999, edited by Michael Farrell.

29. *Jesus 2000,* 7, has statements by Sister Wendy and Janet McKenzie, contradicting each other on this point. Neither the artist nor Sister Wendy refer to the figure as a Black man; Sister Wendy says the painting is "a haunting image of a peasant Jesus—dark, thick-lipped, looking out at us with ineffable dignity"; and McKenzie does not characterize her figure, except to say that together with the symbols he is intended to convey the idea that "Jesus is in all of us." Ibid.

30. Greg Bischof, "Artist Depicts Christ for New Millennium," Corpus Christi *Caller-Times,* January 1, 2000, D11.

31. Her work is available on the Internet at www.bridgebuilding.com/catalog/jm1.html.

How Some Scholars Deal
with the Question

1. Susan Sontag, "Notes on 'Camp,' " in *Against Interpretation* (New York: Dell, 1969), 275–92.

2. Kuspit is perhaps the best example of how a widely published writer can still be ostracized by the academic community when the work is seen to depend too much on issues of religion or spirituality. See Donald Kuspit, "Reconsidering the Spiritual in Art," *Art Criticism* 17, no. 2 (2002): 55–69, a position paper on modernism as spiritual crisis, taking Kandinsky as a model and example. Robert Rosemblum's writing on spirituality can be approached through his *Modern Painting and the Northern Romantic Tradition: Friedrich to Rothko* (New York: Harper, 1975).

3. See Joseph Mascheck's critique of Catholicism's spurning of abstraction in "Abstract Art and Religious Belief," *America* 168 (1992): 114–19. In that essay he asks why "our church and people, so de-Tridentified in other respects, cling to a fundamentally Counter-Reformational, now naïvely pictorial-naturalistic sense of painting and sculpture" (ibid., 114). For the art-world perspective see Mascheck, "Iconicity," *Artforum* 17 (1979): 30–41; and Mascheck et al., "Cruciformality," *Artforum* 15 (1977): 56–73. He has expressed his alienation from the secularized art world on several occasions. "My only disappointment as editor [of Artforum]," he wrote in 1993, "was the cynical derision that met any religious reference." Mascheck, "Yours Faith-

fully, Joseph Mascheck," *Artforum* International 32 (1993): 124. I thank Ed
Schad for bringing Mascheck's essays to my attention.

4. Karl Werckmeister, "A Critique of T.J. Clark's *Farewell to an Idea*," in *Critical Inquiry* 28, no. 4 (2002): 855–67, quotation on p. 864. Werckmeister's
argument depends on Clark's reading of a passage in Hegel's *Phenomenology of the Spirit*; my own sense is that Clark's treatment of Hegel is too allusive
to make it certain that Werckmeister's reading has any purchase. It is instructive to compare Karsten Harries's review of Clark's book, because Harries
argues that modern art achieves transcendence through matter and material. "What is being transcended" in passages of apparently pure nonrepresentational paint, Harries writes, "is the reach of our concepts and words."
In my reading, Harries's formulations are too quick: they fail to take notice
of the fact that the material's very resistance is what gives the art its grip on
the modernist imagination. Harries, "Review of Clark, *Farewell to an Idea*,"
in *The Art Bulletin* 83, no. 2 (2001): 358–64, quotation on p. 360.

5. Alain Besançon, *The Forbidden Image: An Intellectual History of Iconoclasm*, translated by Jane Marie Todd (Chicago: University of Chicago Press,
2000), 221, and compare 229.

6. The quotation is from Sally Promey, "The 'Return' of Religion in the Scholarship of American Art," *Art Bulletin* 85, no. 3 (2003): 581–603, quotation
on p. 598. See also Kimberley Pinder, " 'Our Father God; Our Brother Christ
or Are We Bastard Kin?': Images of the Suffering Christ in African American
Painting, 1924–45," in *African American Review* 3, no. 2 (1997): 223–33;
and David Morgan, *Protestants and Pictures: Religion, Visual Culture, and
the Age of American Mass Production* (New York: Oxford University Press,
1999).

7. Theirry De Duve, *Look, One Hundred Years of Contemporary Art*, translated by Simon Pleasance and Fronza Woods (Brussels: Ludion, c. 2000).

8. De Duve suggests Manet might have read Ernest Renan's *Life of Jesus*, published the year before, which proposed a human Jesus is sufficient for Christianity. De Duve says there is no evidence Manet knew of the book, but even
if he did, the painting's range of references is wider than Renan's humanized Jesus. De Duve, *Look*, 13.

9. De Duve, *Look*, 14. I have paraphrased this. What De Duve actually says is
"[Malevich] was inoculating the tradition of the Russian icon with a vaccine
capable of preserving its human meaning, for a period which faith in God
could no longer keep alive." But in that sentence, the antecedent of "alive"
is "period," implying faith could not sustain the period. I take it he means
faith couldn't sustain "human meaning."

10. De Duve, *Look*, 14–15.

11. De Duve, *Look*, 15.

12. De Duve, *Look*, 18, 27. Compare the reading by Joan Copjec, in the essay
"Moses the Egyptian and the Big Black Mammy of the Antebellum South:
Freud (with Kara Walker) on Race and History," in Copjec, *Imagine There's
No Woman: Ethics and Sublimation* (Cambridge, MA: MIT Press, 2002),
82–107, especially p. 104, where she argues that "De Duve's critical argument ... is that it is not as God but as man that Christ will resurrect himself." My reading of De Duve's text is at variance with Copjec's.

Kim's Story Explained:
The End of Religious Art

1. *Icons of American Protestantism,* edited by David Morgan (New Haven, CT: Yale University Press, 1996).
2. *Late Night with Conan O'Brien,* September 27, 2001.
3. Frédéric Debuyst, *L'Art Chrétien contemporain de 1962 à nos jours* (Paris: Mame, 1988), 12.
4. Robert Henkes, *The Spiritual Art of Abraham Rattner: In Search of Oneness* (Lanham, MD: University Press of America, 1998), 8.
5. *Existenz und Rückbindung: Zum religiösen Werk von Hans Fronius,* edited by Ferdinand Reisinger and Peter Assmann (Linz: OÖ. Landesmuseum, 1995), exh. cat.
6. Ferdinand Reisinger, "Ecce dolor—welch ein Schmertz (Zur Pietà)," in *Existenz und Rückbindung,* 102–6.
7. John Dillenberger, *The Visual Arts and Christianity in America, From the Colonial Period to the Present,* expanded edition (New York: Crossroad, 1989).
8. Kathleen Regier, *The Spiritual Image in Modern Art,* edited by Kathleen Regier (Wheaton, IL: Theosophical Publishing House, 1987).
9. Paul Tillich, "Art and Ultimate Reality," in *Art, Creativity, and the Sacred* (New York: Continuum, 1995), 233.
10. See my *Pictures and Tears: A History of People who Have Cried Over Paintings* (New York: Routledge, 2001), 1–19; religious aspects of the Rothko Chapel are also brought out in David Summers, *Real Spaces: World Art History and the Rise of Western Modernism* (London: Phaidon, 2003), 643–52.
11. Von Ogden Vogt, *Art and Religion* (New Haven, CT: Yale University Press, 1921), 9.
12. *Revelations: Artists Look at Religions,* exh. cat. (Chicago: The School of the Art Institute, 1991).
13. *Heaven,* exh. cat., edited by Doreet Levitte Harten (Ostfildern: Hatje Cantz, 1999), 186–89.
14. Olga Tobreluts, "Manifesto," personal communication, New Academy of Fine Arts, St. Petersburg, December 20, 2003.
15. Georg Wilhelm Friedrich Hegel, *Aesthetics: Lectures on Fine Arts,* translated by T.M. Knox, 2 vols. (Oxford: Clarendon Press, 1975), 606.

Rehema's Story Explained:
The Creation of New Faiths

1. Michael York, *The Emerging Network: A Sociology of New Age and Neopagan Movements* (Lanham, MD: Rowan and Littlefield, 1995).
2. Martin Bernal, *Black Athena: The Afroasiatic Roots of Classical Civilization,* 2 vols. (New Brunswick, NJ: Rutgers University Press, 1987–91), especially vol. 1, *The Fabrication of Ancient Greece, 1785–1985.*
3. York, *The Emerging Network,* 305.
4. The two discourses often address similar subjects, and at a comparable level of rigor. See for example Carol Becker, "Brooklyn Museum: Messing with

the Sacred," in *Surpassing the Spectacle: Global Transformations and the Changing Politics of Art* (Lanham, MD: Rowman and Littlefield, 2002), 43–58.

5. Illustrated in Kay Turner, *Beautiful Necessity: The Art and Meaning of Women's Alters* (London: Thames & Hudson, 1999), 126.

6. Here one of the most prominent examples is Donald Kuspit, although his work depends more on psychoanalysis and its tropes of sublimation, redemption, and transfiguration than on NRMs. There is a parallel, however, in his willingness to write about religious meanings and influences; and he is perhaps the best example of how a widely published writer can still be ostracized by the academic community when the work is seen to depend too much on issues of religion or spirituality. See Kuspit, "Reconsidering the Spiritual in Art," *Art Criticism* 17, no. 2 (2002): 55–69, a position paper on modernism as spiritual crisis, taking Kandinsky as an example.

7. For example "Haitian Studio Photography: A Hidden World of Images," *Aperture* 126 (1992): 58–65.

8. Suzi Gablik, *The Reenchantment of Art* (London: Thames and Hudson, 1991), 50.

9. Gablik, *Reenchantment*, 53.

10. See for example John Pfeiffer, *The Creative Explosion: An Inquiry into the Origins of Art and Religion* (New York: Harper and Row, 1982).

11. Marija Gimbutas, *The Civilization of the Goddess* (San Francisco: Harper, 1991). See also Gananath Obeyesekere, *Medusa's Hair, an Essay on Personal Symbols and Religious Experience* (Chicago: University of Chicago Press, 1981), reviewed by S.D. Glazier in *Reviews in Anthropology* 9 (1982): 245; Raymond Firth, *Symbols: Public and Private* (Ithaca, NY: Cornell University Press, 1973); and Gerhold Becker, *Die Ursymbole in den Religionen* (Graz: Styria, 1987). The lineage of such interpretations goes back significantly further; for example Albert Churchward, *The Signs and Symbols of Primordial Man, Being an Explanation of the Evolution of Religious Doctrines from the Eschatology of the Ancient Egyptians* (New York: E.P. Dutton, 1910). It is not often noted among writers interested in feminist re-readings of history that Lucretius's *De rerum natura* contains one of the very few uses of the feminine creatrix as opposed to the masculine creator. See Aksel Haaning, "The Notion of the 'Light of Nature' in Medieval and Renaissance Thought," *Readings in Philosophy and Science Studies,* vol. 1, edited by Vincent Hendricks and Joseph Ryberg (Copenhagen: Roskilde University, 2001), 9–25, especially p. 13.

12. For example, *Neglected Wells: Spirituality and the Arts,* edited by Anne Murphy and Eoin Cassidy (Dublin: Four Courts, 1997).

13. Margaret Conkey and Ruth Tringham, "Archaeology and the Goddess: Exploring the Contours of Feminist Archaeology," in *Feminisms in the Academy,* edited by Donna Stanton and Abigail Stewart (Ann Arbor, MI: University of Michigan Press, 1995), 199–247; and Ruth Tringham, "Review of Civilization of the Goddess," in *American Anthropologist* 95 (1993): 196–97.

14. Mircea Eliade, in *Art, Creativity, and the Sacred: An Anthology in Religion and Art,* edited by Diane Apostolos-Cappadona (New York: Continuum, 1996), 181, 182.

15. Mary Nelson, *Artists of the Spirit: New Prophets in Art and Mysticism* (Sonoma, CA: Arcus, 1994), n.p., p. 1 respectively.
16. *Revelations: The Transformative Impulse in Recent Art*, exh. cat., edited by David Floria (Aspen, CO: Aspen Art Museum, 1989), 16.
17. *Revelations: The Transformative Impulse in Recent Art*, 12.
18. See Odd Nerdrum et al., *On Kitsch* (Oslo: Kagge, 2001), 7; and see Alan Jolis, "Odd Man In," *ArtNews* (1999): 118–20.
19. *Adolf Wölfli: Draftsman, Writer, Poet, Composer*, edited by Elka Spoerri et al (Ithaca, NY: Cornell University Press, 1997). Darger is the subject of ongoing research. See John MacGregor, *Henry Darger: In the Realms of the Unreal* (New York: Delano Greenridge Editions, 2002).
20. Roger Cardinal, *Outsider Art* (New York: Praeger Publishers, 1972); and *The Artist Outsider: Creativity and the Boundaries of Culture*, edited by Michael D. Hall, Eugene W. Metcalf, Jr., and Roger Cardinal (Washington, DC: Smithsonian Institution Press, 1994). Outsider art is widely debated. The best text I know is Rebecca Mazzei, "The Problems with Outsider Art," MA thesis, School of the Art Institute of Chicago, 2003, unpublished.
21. Nerdrum, *On Kitsch*. Nerdrum's misdefinition of kitsch may shield him from the awareness that his work owes more to artists like von Stuck than to his declared model, Rembrandt. (In *On Kitsch* Nerdrum mentions Anders Zorn, Edvard Munch, Akseli Gallen-Kallela, and Puvis de Chavannes, who are all closer models than Rembrandt.)
22. Jeffrey Hayes, *Signs of Inspiration: The Art of Prophet William J. Blackmon* (Milwaukee WI: Patrick and Beatrice Haggerty Museum of Art, 1999).
23. *Free Within Ourselves: African-American Artists in the Collection of the National Museum of American Art*, exh. cat., edited by Regina Perry (Washington, DC: Smithsonian Institution, 1992), 80–85. I thank Kym Pinder for bringing my attention to this book.
24. Kay Turner, *Beautiful Necessity: The Art and Meaning of Women's Altars* (London: Thames and Hudson, 1999), 74–75. For Betye Saar see Jane Carpenter and Betye Saar, Betye Saar (San Francisco: Pomegranate, 2003).
25. Turner, *Beautiful Necessity*, 74, 136, 128 respectively.
26. *Revelations: The Transformative Impulse in Recent Art*, 26.
27. Turner, *Beautiful Necessity*, 30.
28. Roger Lipsey, *An Art of Our Own: The Spiritual in Twentieth-Century Art* (Boston: Shambhala, 1997).
29. *L'Ombra della Ragione: l'idea del sacro nell'identità Europea nel XX secolo*, exh. cat., edited by Danilo Eccher (Bologna: Galleria de'Arte Moderna, 2000), 19.
30. *L'Ombra della Ragione*, 19, 25.
31. *L'Ombra della Ragione*, 65, 68.

Brian's Story Explained:
Art that Is Critical of Religion

1. See Jane Dillenberger, *The Religious Art of Andy Warhol* (New York: Continuum, 1998), and the review by Eleanor Heartney, "Andy's Icons," *Art in America* 87, no. 6 (1999): 35–37. Dillenberger argues that the *Last Supper*

paintings most intensely embody Warhol's Catholicism; Heartney suggests the early work, including the images of electric chairs, is in the end evidence of a "more profound spiritual consciousness" (ibid., 37).

2. Harold Bloom, *The American Religion: The Emergence of the Post-Christian Nation* (New York : Simon & Schuster, 1992).

3. Friedrich Max Müller, *Lectures on the Origin and Growth of Religion, As Illustrated by the Religion of India* (Varanasi: Indological Book House, 1964 [1878]), 218, and *The Life and Letters of the Right Honorable Friedrich Max Müller,* 2 vols. (New York: Longmans and Green, 1902).

4. Spinoza, "Theologico-Political Treatise," in *A Theologico-Political Treatise and a Political Treatise,* translated by R.H.M. Elwes (New York, 1951), 173.

5. See André Jean Festugiere, *Epicurus and His Gods (Epicure et ses dieux),* translated by C.W. Chilton (New York: Russell and Russell, 1969), and *Varieties of Unbelief: From Epicurus to Sartre,* edited with an introduction, notes, and bibliography by J.C.A. Gaskin (New York: Macmillan, 1989).

6. Freud, *The Future of an Illusion,* translated and edited by James Strachey (New York: Norton, 1975), and see Anthony De Luca, *Freud and Future Religious Experience* (New York: Philosophical Library, 1976).

7. According to E. Wallis Budge, in *Amulets and Superstitions* (New York: Dover, 1978 [1930]), where it is described without a footnote on p. 331.

8. *The Hours of Catherine of Cleves,* edited by John Plummer (New York: George Braziller, 1966).

9. At the Cranbrook Academy of Art, for example, some floor tiles use patterns of crosses, swastikas, and sauvastikas; the tiles were laid in the 1920s. In Western usage, sauvastikas are reversed swastikas; but in Jain usage the term can be applied to a "clockwise" swastika as well.

10. Collette Caillat and Ravi Kumar, *The Jain Cosmology* (Basel: Ravi Kumar, 1981); Jyotindra Jain and Eberhard Fischer, *Jaina Iconography,* 2 vols. (Leiden: E.J. Brill, 1978), vol. 1, pl. VI (a), VII (a), and XV (b); B.C. Bhattacharya, *The Jaina Iconography* (Dehli: Motilal, 1974 [1939]), 14. See also Armand Nevin, *Le Jainisme: Art et iconographie* (Brussels: Association Art Indian, 1976), figs. 55, 56. The four arms represent faith, knowledge, conduct, and penance; the three dots are the "three jewels" of insight, knowledge, and conduct.

11. Hegel, *Aesthetics,* 305, also discussed in Besançon, *Forbidden Image,* 207.

12. *Goddess of the Americas = La diosa de las Américas: Writings on the Virgin of Guadalupe,* edited by Ana Castillo (New York: Riverhead, 1997).

13. Available at http://www.sancta.org/eyes.html.

14. Available at http://www.sixty-five.com/jeffreyvallance/. I thank Ben Meisner for drawing my attention to Vallance's work.

15. *Faith,* edited by Christian Eckart et al. (Ridgefield, CT: Aldrich Museum of Contemporary Art, 2000).

16. The Museum of Contemporary Religious Art (MOCRA) is at the St. Louis University, St. Louis, Missouri. MOCRA opened in 1993 as the first "contemporary interfaith art museum in the world," according to its director, Terrence Dempsey (personal communication, December 2003). Among the critical notices of the museum, see especially Victoria Carlson, "Consecrations at an Exhibition, Religious and Spiritual Art in the Time of AIDS," *The Critic: A Journal of American Catholic Culture* (Summer 1995): 2–17,

and compare Douglas Dreishpoon, "Art's Revenge in the Time of AIDS [review of several exhibitions, including MOCRA's 'Consecrations,' " *Art Journal* 54, no. 4 (1995): 87–91, especially 89–90.

17. For other examples see *Seeing Salvation: Images of Christ in Art*, edited by Neil Mcgregor and Erika Langmuir (London: BBC Worldwide, 2000), and the Museum of Contemporary Spiritual Art in the Tryitarska Tower in Lublin, Poland. I thank Ann MaCoy and Terrence Dempsey for bringing these to my attention.

Ria's Story Explained: How Artists Try to Burn Away Religion

1. For Fichte's and Schelling's sense of religion, see the studies in *Sein und Schein der Religion*, edited by Alois Halder et al. (Düsseldorf: Patmos, 1983).

2. George Inness, "A Painter on Painting," originally published in *Harper's New Monthly Magazine* 56 (February 1878), quoted for example in *George Inness: The Spiritual Landscape*, exh. cat. (New York: Borghi, 1991), n.p.

3. Stephanie Walker, "Lives of the Avant-Garde Artist: Emily Carr and William Kurelik," in *Art and Interreligious Dialogue: Six Perspectives,* edited by Michael Bird (Lanham, MD: University Press of America, 1995), 73–96.

4. For Blavatsky see first the critical account by Peter Washington, *Madame Blavasky's Baboon: A History of the Mystics, Mediums, and Misfits Who Brought Spiritualism to America* (New York: Schocken, 1995); and for further research, *Theosophy in the Nineteenth Century: An Annotated Bibliography*, edited by Michael Gomes (New York: Garland, 1994).

5. Eduard Schuré, *Les grands initiés: Histoire secrète des religions*, in English as *The Great Initiates: A Study of the Secret History of Religions*, translated by Gloria Rasberry (San Francisco: Harper and Row, 1961). Besançon, *Forbidden Image*, 312–13, notes that in 1960 Schuré's book was in its 91st edition.

6. Papus [Gérard d'Encausse], *Du Traitement externe et psychique des maladies nerveuses: aimants et couronnes magnétiques—miroirs—traitement diététique—hypnotisme—suggestions—transferts* (Paris: Chamuel, 1897); Papus, *The Tarot of the Bohemians: The Most Ancient Book in the World,* translated by A.P. Morton (London: G. Redway, 1986); *Corpus Hermeticum,* edited by Arthur Darby Nock and André Jean Festugière, 2 vols. (Paris: Belles Lettrs, 1991–); and Petr Dem'ianovich Uspenskii (in the older transliteration, Petyr Demaniovich Ouspensky), Tertium *Organum: The Third Canon of Thought, a Key to the Enigmas of the World*, translated by Nicholas Bessaraboff and Claude Bragdon (New York: Vintage, 1970). For Swedenborg and George Inness, see Rachael Ziady DeLue, "George Inness: Landscape, Representation, and the Struggle of Vision," Ph.D. dissertation, Johns Hopkins University, 2000, 89. DeLue's study is forthcoming as a book from University of Chicago Press.

7. Rudolf Steiner, "The Supersensible Origin of the Arts," in *Art as Spiritual Activity: Rudolf Steiner's Contribution to the Visual Arts*, edited by Michael Howard (Hudson, NY: Anthroposophic Press, 1998), 237–29, quotation on pp. 242–43.

8. *Perceptions of the Spirit in Twentieth-Century American Art*, edited by Jane Dillenberger and John Dillenberger (Indianapolis, IN: Indianapolis Museum of Art, 1977); *The Spiritual in Art: Abstract Painting 1890–1985*, edited by Maurice Tuchman (New York: Abbeville, 1985).

9. Maurice Tuchman, "Hidden Meanings in Abstract Art," in *The Spiritual in Art*, 17.

10. *Charmion von Wiegand: Spirituality in Abstraction, 1945–1969*, exh. cat. (New York: Michael Rosenfeld Gallery, 2000), 6.

11. *The Non-Spiritual in Art: Abstract Painting 1985–????*, edited by Kevin Maginnis, exh. cat. (Chicago: Maginnis Graphics, 1987), 9.

12. Michael Fried, *Menzel's Realism: Art and Embodiment in Nineteenth-Century Berlin* (New Haven: Yale University Press, 2002), 76, 232 respectively. Against Fried's answer to Clark it could be argued that the painting in question embodies a Romantic aesthetic (of the fragment, the dispersed whole) and therefore asks to be seen as modernist in a different sense, or in a different genealogy, than Clark intends. Part of Clark's context for "disenchantment"—the term, and development, that concerns him—is in *Farewell to an Idea: Episodes From a Hisory of Modernism* (New Haven, CT: Yale University Press, 1999), 372.

13. Rose-Carol Washton Long, *Kandinsky: The Development of an Abstract Style* (Oxford: Oxford University Press, 1980).

14. Dillenberger, *The Visual Arts and Christianity*, 198.

15. Eliade, "The Sacred and the Modern Artist [1964]," in *Art, Creativity, and the Sacred*, 179–83, quotations on p. 179.

16. For a discussion of the Greek terms see Christian Tornau, *Plotin Enneaden VI 4–5* (Stuttgart: B.G. Teubner, 1998), 446.

17. Plotinus, *Enneads*, translated by Stephen MacKenna (London: Faber and Faber, 1956), VI.7.33, p. 587, translation modified; the section is also discussed in Besançon, *Forbidden Image*, 52.

18. Plotinus, *Enneads*, VI.7.33, p. 588.

19. Plotinus, *Enneads*, V.5.7, pp. 408–9.

20. *Kena Upanishad*, I.6, in *The Thirteen Principal Upanishads*, translated by Robert Ernest Hume (Dehli: Oxford University Press, 1995 [1887]), 336. See further Narayanrao Appurao Nikam, *Ten Principal Upanishads: A Dialectic and Analytical Study* (Bombay: Somaiya, 1974), 99–110.

21. For Byzantine art, see André Grabar, *Les Origines de l'esthétique médiévale* (Paris: Macula, 1992), 33. For Plotinian influence in contemporary thought, see Moshe Barasch, *Icon: Studies in the History of an Idea* (New York: New York University Press, 1992). Barasch's title is modeled on Erwin Panofsky's *Idea: A Concept in Art Theory*, translated by Joseph Peake (Columbia, SC: University of South Carolina Press, 1968), which also touches on Plotinian themes. For this study, the following is also relevant: Oliver Davies, "Thinking Difference: A Comparative Study of Gilles Deleuze, Plotinus, and Meister Ekhart," in *Deleuze and Religion*, edited by Mary Bryden (London: Routledge, 2001). Davies is also an apologist for Celtic Christianity.

22. Rosalind Krauss and Yve-Alain Bois, *Formless: A User's Guide* (New York: Zone, 1997). My own work on the unrepresentable, the unpicturable, and the inconceivable is also in the Plotinian tradition. See my *Pictures of the Body: Pain and Metamorphosis* (Stanford: Stanford University Press, 1999),

and *On Pictures and the Words that Fail Them* (Cambridge: Cambridge University Press, 1997). I thank Barbara Stafford for pointing out the Plotinian antioptical ontology in my work.

23. Ajit Mookerjee, *Ritual Art of India* (London: Thames and Hudson, 1985), pl. 42; Sylvia Matheson and R. Beny, *Rajasthan, Land of Kings* (Lausanne: Vendôme, 1984), pl. 41. A good introduction to popular Hindu altars is Jyotindra Jain, "Der hinduistische Altar: Zwischen Kult und Zurschaustellung," in *Altäre: Kunst zum Niederknien,* edited by Jean-Hubert Martin (Düseldorf: Kunst Palast, 2001), 162–79. I thank Jutta Jain-Neubauer for drawing my attention to this essay.

24. Their ceremony is related to an astonishingly intricate ancient form of fireworship called *agnicayana* (अग्निनचयन piling of agni), one of the world's most complicated and ancient surviving rituals, performed only in Panjal, Kerala. See Frits Staal, C.V. Somayajipad, and M. Itti Ravi Nambudiri, *Agni: The Vedic Ritual of The Fire Altar,* with photographs by Adelaide de Menil (Berkeley: Asian Humanities Press, 1983); also Yasuke Ikari, "A Study of Agnicayana, Ukhasambharana," Ph.D. dissertation, University of Chicago, 1981, unpublished. A useful sourcebook is Chitrabhanu Sen, *A Dictionary of the Vedic Rituals, Based on the Śrauta and Grhya Sūtras* (Delhi: Concept Publishing Company, 1978). The book *Agni* has recently been reprinted (Delhi: Motilal, 2001).

25. See Besançon, *Forbidden Image,* 189, 221, 226, quoting Hegel, *Aesthetics,* 885; for a good account see Martha Hollander, *An Entrance for the Eyes: Space and Meaning in Seventeenth-Century Dutch Art* (Berkeley: University of California Press, 2002).

26. Carus, *Neun Briefe über Landschaftsmalerei zuvor ein Brief von Goethe als Einleitung* (Los Angeles: Getty Research Institute, 2002 [1831]), cited in Besançon, *Forbidden Image,* 289, from the French edition *Neuf lettres sur la peinture de paysage dans l'Allemagne romantique,* translated by Erika Dickenherr (Paris: Klincksieck, 1983), 131.

27. Ursula Härtung, *Frans Francken der Jüngere (1581–1642)* (Freren: Luca-Verlag, 1989), cat. 460, p. 373; and cp. p. 85, fig. 78. I have not been able to determine why the painting identified as *The Study of a Collector,* which seems to be the same painting, is credited by Mario Praz to the "M. Goffi collection, Rome." Praz, *La filosofia dell'arredamento,* translated by William Weaver as *An Illustrated History of Interior Decoration, From Pompeii to Art Nouveau* (London: Thames and Hudson, 1983 [1964]), 101, pl. 68.

28. *The Books of Anselm Kiefer 1969–1990,* edited by Götz Adriani (New York: Braziller, 1990), 34.

29. Evans-Pritchard, *Theories of Primitive Religion* (Oxford: Clarendon Press, 1965), 104.

30. See Pritchard's essay "The Intellectualist (English) Interpretation of Magic," *Bulletin of the Faculty of Arts, Egyptian University* (Cairo) 1 part 2 (1933): 282–311.

31. Evans-Pritchard, *Theories of Primitive Religion,* 79, citing Lucien Lévy-Bruhl, *Les Fonctions mentales dans les sociétés inférieurs* (Paris: F. Alcan, 1910), translated as *How Natives Think* (Princeton: Princeton University Press, 1985 [1926]); and see Durkheim, *The Elementary Forms of the Religious Life* (New York: Oxford University Press, 2001 [1915]), book III, chapter 7.

32. Marcel Mauss, "Essai sur les variations saisonnières des sociétés Eskimos. Étude de morphologie sociale," *L'Année sociologique* 9 (1906): 97–98. *L'Année sociologique* was Durkheim's journal.

33. Marcelin Pleynet, "Art et l'histoire de l'art," *Documents sur 6/7/8* (1980): 4, discussed in Stephen Bann, *The True Vine: On Visual Representation and the Western Tradition* (Cambridge: Cambridge University Press, 1989), 250.

34. John Berger, *Ways of Seeing, Based on the BBC Television Series with John Berger* (London : British Broadcasting Corporation and Penguin Books, 1986), 21.

35. For an introduction to Chadwick see *Stilled Lives: Helen Chadwick,* with essays by Marina Warner and others (London: Portfolio Gallery, 1996).

36. *Contemplations on the Spiritual,* edited by Ken Mitchell (Glasgow: Glasgow School of Art, n.d. [c. 2001]), quotations on p. 4.

37. *Contemplations on the Spiritual,* 2.

38. *Oxford English Dictionary,* v. "sacred."

39. Taylor, *Para/Inquiry: Postmodern Religion and Culture* (London: Routledge, 2000), 119.

40. Taylor, *Para/Inquiry,* 118.

41. Taylor, *Para/Inquiry,* 103.

42. Hammarsköld is quoted in Roger Lipsey, *An Art of Our Own: The Spiritual in Twentieth-Century Art* (Boston: Shambhala, 1988), 453. Nevelson, Rothko: Jane and John Dillenberger are quoted in *Perceptions of the Spirit in Twentieth-Century American Art* (Indianapolis, IN: Indianapolis Museum of Art, 1978), 110–11, 132–33. *Bill Viola: Unseen Images = nie gesehen Bilder = images jamais vues,* edited by Maries Luise Syring (Düsseldorf: R. Meyer, 1992), 100.

Joel's Story Explained:
Unconscious Religion

1. Thomas Weiskel, *The Romantic Sublime: Studies in the Structure and Psychology of Transcendence* (Baltimore: Johns Hopkins University Press, 1976), 3.

2. Most recently: *The Sticky Sublime,* edited by Bill Beckley (New York: Allworth, 2001). Most interestingly: Dave Hickey, *The Invisible Dragon: Four Essays on Beauty* (Los Angeles: Art Issues Press, 1993).

3. Neil Hertz, *The End of the Line: Essays on Psychoanalysis and the Sublime* (New York: Columbia University Press, 1985). This painting is the best known of an unexpectedly large number of Courbet's paintings of the same theme, most in private collections.

4. The background is a text by Michael Fried, *Courbet's Realism* (Chicago: University of Chicago Press, 1990).

5. Guy Sircello, "Beauty in Shards and Fragments," *Journal of Aesthetics and Art Criticism* 48 (1990): 21–35.

6. See especially Jean-François Lyotard, *Lessons on the Analytic of the Sublime,* translated by Elizabeth Rottenberg (Stanford: Stanford University Press, 1994), and *Of the Sublime: Presence in Question,* translated and edited by Jeffrey Librett (Albany, NY: State University of New York Press, 1993).

7. Nicholas Tomalin and Ron Hall, *The Strange Last Voyage of Donald Crowhurst* (Camden, ME: International Marine/McGraw-Hill, 1995 [1970]), 241. I thank Timothy Straveler for bringing this book to my attention.

8. Cayman Brac is one of the Cayman Islands. Ticita Dean, *Teignmouth Electron* (London: Book Works, 1999).

9. Hegel, *Aesthetics*, 319.

10. Besançon, *Forbidden Image,* 225. He generalizes the phenomenon to expressionism, which does not make as much sense by Hegel's standards because expressionist artists did not often produce obscure, monstrous, and arbitrary forms.

11. Joel-Peter Witkin, "Divine Revolt," *Aperture* 100 (1985): 34–41, quotation on p. 35.

12. Max Kozloff, "Contention Between Two Critics About a Disagreeable Beauty," *Artforum* 22 (1984): 45–53.

13. The video is by Leina Bocar (2002).

14. Quoted in Matthew Fox, *Breakthrough: Meister Ekhart's Creation Spirituality in New Translation* (New York: Doubleday, 1977), 4.

Some Words to Describe Spiritual Art

1. Rudolf Otto, *The Idea of the Holy, An Inquiry into the Non-rational Factor in the Idea of the Divine and its Relation to the Rational,* translated by John W. Harvey (New York: Oxford University Press, 1950), 5, and see Leon Schlamm, "Numinous Experience and Religious Language," *Religious Studies* 28 (1992): 533–51.

2. Michael Stoeber, "Introvertive Mystical Experiences: Monistic, Theistic, and the Theo-Monistic," *Religious Studies* 29 (1993): 169–84.

3. For Böhme it is best to start with Andrew Weeks, *Böhme: An Intellectual Biography of the Seventeenth-Century Philosopher and Mystic* (Albany: State University of New York, 1991). Older translations and especially Jungian interpretations can be misleading. See also Weeks, *German Mysticism from Hildegard of Bingen to Ludwig Wittgenstein* (Albany: State University of New York, 1993).

4. Thomas Huxley, "Agnosticism and Christianity," in *Science and Christian Tradition* (New York: D. Appleton, 1900 [1889]), 310. Huxley ridicules Cardinal John Henry Newman's statement "Let us maintain, before we have proved. This seeming paradox is the secret of happiness." Ibid., 312 n., citing Newman, *Tract Ninety* (London: Constable, 1933), 85.

5. For the ontological proof, see St. Anselm, *Proslogion,* in *The Many-Faced Argument, Recent Studies on the Ontological Argument for the Existence of God,* edited by John Hick and Arthur McGill (New York: Macmillan, 1967), 3–6, and the brilliant, quirky book by Ermanno Bencivenga, *Logic and Other Nonsense: The Case of Anselm and his God* (Princeton: Princeton University Press, 1993).

6. The best book on this subject is Michael Sellis, *Mystical Languages of Unsaying* (Chicago: University of Chicago Press, 1994), which consists of close readings of several writers who worked during a "flowering" of apophatic thinking from the mid-12th to the beginning of the 14th centuries.

Sellis does not claim the writers—who range from Rumi (d. 1275) and Ibn 'Arabi (d. 1240) to Marguerite Porete (d. 1310) and Meister Eckhart (d. c. 1327) are connected, but that their writing exhibits similar features (ibid., 5).

7. For the texts of the Pseudo-Dionysius, see *Dionysiaca, recueil donnant l'ensemble des traductions latines des ouvrages attribués au Denys de l'Aréopage,* edited by Philippe Chevallier (Paris: Desclée, 1937), 2 vols, especially vol. 1, *De mystica theologia,* 563 ff. For negative theology in recent literary theory, see the references in Mark C. Taylor, "Non-negative Negative Atheology," *Diacritics* 20, no. 4 (1990): 2–16.

8. This schema of three responses (silence, dialectics, and apophatics) is from Sellis, *Mystical Languages,* 2, 207.

9. Czeslaw Milosz, "Science Fiction and the Coming of the Antichrist," in *Emperor of the Earth: Modes of Eccentric Vision* (Berkeley: University of California Press, 1977), 22–23, quoting from Vladimir Solovyov, *Three Conversations on War, Progress, and the End of World History, Including a Short Tale of the Antichrist and Supplements* (1900).

10. Hans Jonas, *The Gnostic Religion, The Message of an Alien God and the Beginnings of Christianity,* 2nd ed. (Boston: Beacon Press, 1963), 49.

11. Bimal Krishna Matilal, "Mysticism and Ineffability: Some Issues of Logic and Language," in *Mysticism and Language,* edited by Steven Katz (New York: Oxford University Press, 1992), 143–57, especially p. 153. Most references are in the Br̥ihad-Āran̄yaka Upanishad, 2.3.6, 3.9.26, and 4.2.4. See *Thirteen Principal Upanishads,* 40 and 97, 125, 153 respectively.

12. For a word-by-word analysis see Swami Chinmayananda, *Discourses on Kenopaniṣad* (Madras: Chinmaya Publications Trust, 1978 [1952]), 58–63.

13. John Grimes, *A Concise Dictionary of Indian Philosophy* (Albany, NY: State University of New York Press, 1996), 89, 203, 206.

14. Natalia Isayeva, *From Early Vedanta to Kashmir Shaivism: Gaudapada, Bharthari, and Abhinavagupta* (Albany, NY: State University of New York, 1995), 24, 138.

15. Dionysius "Mystic Theology," in *The Works of Dionysius the Areopagite,* translated by John Parker (Merrick, NY: Richwood, 1976 [1897–99]), Part I, 137, translation modified.

16. See William Johnston, *The Mysticism of the Cloud of Unknowing, A Modern Interpretation,* with a foreword by Thomas Merton (New York: Desclee, 1967).

17. Mark C. Taylor, *Disfiguring: Art, Architecture, Religion* (Chicago: University of Chicago Press, 1992), 316.

18. Blanchot, translation modified, quoted in Taylor, *Disfiguring,* 314.

19. Taylor, *Disfiguring,* 305.

20. Taylor, *Disfiguring,* 307.

21. See Ernst Halter and Martin Müller, *Der Weltuntergang, Mit einem Lesebuch,* exh. cat. (Zürich: Offizin, 1999), 265.

22. Von Moos's range of styles can be seen in *Max von Moos (1903–1979)* (Lucerne: Mengis and Sticher, 1984). Another artist who is a predecessor in this regard is Rolf Iseli: see *Rolf Iseli,* exh. cat. ., edited by Erika Billeter et al. (Lausanne: La Musée, 1990). I thank Joseph Grigely for bringing Iseli to my attention.

23. John Caputo, *The Prayers and Tears of Jacques Derrida: Religion Without Religion* (Bloomington, IN: Indiana University Press, 1997); Amy Hollywood, *Sensible Ecstasy: Mysticism, Sexual Difference, and the Demands of History* (Chicago: University of Chicago Press, 2002); and Jacques Derrida, *Acts of Religion* (New York: Routledge, 2002).

24. Caputo, *Prayers and Tears;* Caputo, *On Religion* (New York: Routledge, 2001), and *Questioning God,* edited by Caputo et al. (Bloomington, IN: Indiana University Press, 2001). I thank David Morgan for drawing Caputo to my attention.

25. See in this respect David Morgan's criticism of Alain Besançon's *Forbidden Image:* because Besançon is an "intellectual genealogist," Morgan writes, he "regards modernity as secular and modern institutional religion as essentially vestigial" and so he omits popular religious art from his book. This is analogous to the observation I made above regarding Thierry De Duve's sense of the loss of faith. The gulf between those who take Western philosophical secularism as the only reasonable starting point and those who attempt to encompass ongoing organized religions is enormous. Morgan, "The Vicissitudes of Seeing: Iconoclasm and Idolatry [review article]," *Religion* 33 (2003): 170–80.

26. Žižek, *The Spectre Is Still Roaming Around!,* 60–61. Žižek, *On Belief* (London: Routledge, 2001), argues differently, in particular that "Christianity is, from its very inception, THE religion of modernity" (p. 150) and therefore allied to and inseparable from principal artist movements. More recently, Žižek has continued his revival of Marxist-informed Christianity in *The Puppet and the Dwarf: The Perverse Core of Christianity* (Cambridge, MA: MIT Press, 2003).

Index